THE
FUNDAMENTALS
OF DIGITAL
PHOTOGRAPHY

TIM DALY

Fairchild Books
An imprint of Bloomsbury Publishing Plc

50 Bedford Square 1385 Broadway
London New York
WC1B 3DP NY 1001P
UK USA

www.bloomsbury.com

Bloomsbury is a registered trade mark of Bloomsbury Publishing Plc

First published 2014

British Library Cataloguing-in-Publication Data
A catalogue record for this book is available from the British Library.

ISBN: PB: 978-2-9404-9606-8
ePDF: 978-2-9404-4762-6

Daly, Tim, 1964-
The fundamentals of digital photography / Tim Daly.
pages cm
Includes bibliographical references and index.
ISBN 978-2-940496-06-8 (pbk.) -- ISBN 978-2-940447-62-6 (ePDF) 1.
Photography--Digital techniques. I. Title.
TR267.D353 2013
770--dc23
2013021067

Cover designed by Bloomsbury Publishing
Designed by Design by St, London
Printed and bound in China

Chapter 4 106

PROJECT DEVELOPMENT

||

Chapter 5 144

TREATMENT

||

Chapter 6 170

OUTPUT AND FINISHING

||

||

INTRODUCTION

With such labour-saving advances in digital camera and software technology, many of us are increasingly passive about photography, readily accepting the benefits of automated digital production without fully understanding the fundamental principles. We often view our photographic work only on-screen, making review, reflection and development much harder than it need be. Left to dominate, such complex technology can sap our energies and dampen our creative spirit. Through navigating this technology, we often forget the core skills of photography – that of picturing the world in a visually compelling way.

The Fundamentals of Digital Photography has a simple aim, to restore the guiding principles of great photography through efficient and effective technique, while cutting out unnecessary complexity. Once you've got good technique under your belt, you can focus more of your thoughts on tackling the visual problem in front of your lens. To help you explore the creative process we have included some images that have not have been taken using digital cameras, but are as relevant to digital photography as to analogue photography.

My experience of teaching photography has allowed me to observe many emerging talents. All of my keen photography students developed their unique picture-making approach by practice underpinned by a solid understanding of materials and processes. By shooting every week, you will build up your observational strengths and at the same time, explore the full potential of your tools. You'll learn from shooting, reviewing your shoot and then shooting some more. Practice is the key.

PRACTICAL ASSIGNMENTS

Throughout the book, I'll be suggesting that you follow-up your reading with a practical assignment, some of these will be short and some more time-consuming. These tasks are carefully designed to help you put fundamental principles into practice and help you better understand some of the more tricky concepts, which will make little sense unless you explore them with your camera. If you are student of photography, these assignments are ideal material for your research journal, where you can evidence your understanding of the key concepts in photography. I'll be urging you to print lots of things out too – so you can reflect on your efforts, add notes, and keep them all together in a journal rather than scattered across a laptop, desktop or photo-sharing site. Printing will help you work out which images are your strongest.

HOW EQUIPMENT WORKS

The Fundamentals of Digital Photography starts with 'How Equipment Works', outlining all the major items of equipment that you can use to make effective photographs. Using jargon-free language to unpick the practical implications of choosing different kinds of kit, this section describes all the key functions common to most camera brands and models. Comparing a range of camera systems and lenses, you'll be equipped with the knowledge of what's worth investing in and what's not, while being alert to the benefits of using the right tools for the job.

SHOOTING SKILLS

The second chapter, 'Shooting Skills', will guide you through the creative potential of using your camera to visualize great photographs. Here, I'll be showing you how to create different emphasis effects using focus, depth of field and of course, learning how to frame your subjects through the viewfinder. We'll be looking at how to harness the potential of auto-focusing, auto-exposure and all camera settings, putting you in complete control rather than at the mercy of technology.

THEMES AND THEIR WORKFLOWS

Once we've established a solid technical foundation, we'll kick-start our practical work in chapter three: 'Themes and Their Workflows'. Here, through a series of practical challenges, we'll explore photography's major themes, including portraiture, abstract, documentary and landscape. Alongside your shooting task, I'll be asking you to follow a unique digital workflow that I've devised where you'll learn the most effective route for transporting your image files from camera to the final print. Working in this way, you'll learn how to adapt your practical skills to the requirements of the job in hand, and not to get bogged down in software processing.

PROJECT DEVELOPMENT

After you've made some practical work for the first time, chapter four, 'Project Development', plots out the best practice for developing your ideas and giving your work a personal identity. Here, I'll be showing you how to structure a sustained project, how to research your subject and how to learn from other photographers doing similar things. This research will be both visual and conceptual and will alert you to the many different ways of representing your subject or narrating a story. You might be a beachcomber type of photographer – seeking out, unearthing and recording the changing world around you. Or you might be a storytelling photographer – narrating important issues that touch your life. Or you might be more of a director – changing, constructing and structuring the very reality before your eyes.

TREATMENT

The penultimate chapter deals entirely with post-production techniques, which photographers often refer to as 'treatment'. Here, you'll practice core software techniques for enhancing your final images for print. We'll be exploring digital black and white, colour recipes and different ways of adding a visual signature to your prints, avoiding the superficial effects that can be found on millions of photo-sharing websites. You'll be adding just the right amount of digital trickery to make your final images more alluring and you'll be sourcing different materials that will make your work stand out from the crowd.

OUTPUT AND FINISHING

The book closes with the most important chapter of all: 'Output and Finishing'. Here, I'll show you best practice workflows for making inkjet prints at home, using online printing services and for getting the best quality photo books. We'll also look at how to prepare files for use online and how to avoid destroying image quality in that final, most important step.

CHAPTER 1

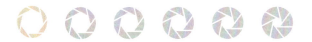

HOW EQUIPMENT WORKS

Many photographers dismiss equipment as functional machinery, employed to turn their vision into a visible product. While this is true, there's still every reason to understand how these tools work and what impact they can have on your workflow. Many great images are spoiled before the shutter has had time to close – because of ill-informed equipment choices made beforehand. Despite the versatility of digital photography, there's simply no substitute for good technique. This chapter outlines the fundamental elements of photographic kit, providing you with all the knowledge that you'll need to make the right selection, whatever your shooting circumstances are.

'Photographers – idiots, of which there are many – say, 'Oh, if only I had a Nikon or a Leica, I could make great photographs.' That's the dumbest thing I ever heard in my life. It's nothing but a matter of seeing, and thinking, and interest.'
Andreas Feininger

DIGITAL SLR CAMERAS

To harness all of your creativity, you'll first need to equip yourself with the most versatile kind of camera: the digital single lens reflex or DSLR. This type of camera provides precision when you need it and flexibility when you need to work quickly.

PRACTICAL USES AND TYPICAL SPECIFICATIONS

DSLR cameras are designed to be portable and quick to press into action, producing enough information to make an exhibition quality print or picture file good enough for the news media. The DSLR differs from the compact camera by its ability to precisely frame a subject through the lens, rather than through a separate viewfinder window or a rear LCD screen. Its image sensor creates between ten to 30 million pixels, capturing more than enough image data for high-quality commercial and creative work.

The design of the DSLR means that it can be used with a wide range of interchangeable accessories, such as special lenses, flash units, remote controllers and external storage media. All DSLRs plug directly into a PC using the universal USB port to enable fast data transfer.

Many cameras also offer HD video capture, which is fast becoming a low-cost alternative for film and TV production. DSLRs use high capacity Compact Flash (CF) or Secure Digital (SD) cards for storing large image files and have additional on-board memory for rapid shooting.

1.1
Simon Barber's clever image is quickly observed and captured at exactly the right moment.

1.1

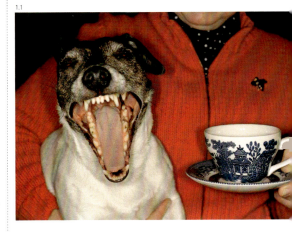

CREATIVE CONTROLS

Essential creative controls, such as aperture, shutter speed and exposure compensation, can be applied manually to suit the circumstances of your shoot. There are also several different metering options to choose from, including centre weighted, matrix and spot. The image sensor has a range of ISO settings from ISO100, for shooting in bright light, up to ISO6400 for low-light conditions. For precise colour management control, the universal Adobe RGB (1998) colour space can be selected instead of the more common sRGB.

PREVIEWS AND CONFIRMATIONS

With a large LCD preview screen, good quality DSLRs provide a Live View function, where you can frame your scene at arms' length rather than using the viewfinder. Review and playback include a zoom function to check sharp focus. For the professional, a useful image histogram can be displayed to check exposure in highlight, midtone and shadow areas. Better cameras are equipped with a depth-of-field preview function, so you can see the consequences of shooting with a specific aperture value.

SENSOR SIZES

DSLRs commonly use one of two image sensor sizes: the small sensor DX or APS-C or the larger FX/Full-Frame sensor. The Full-Frame sensor measures 36x24mm and is the same size as a single frame of 35mm film. Small sensors typically measure 23x15mm, resulting in the cropping of lens focal length. For wide-angle photography, an ultra wide 17mm is needed to give an angle of view corresponding to a 28mm on a 35mm system. FX or Full-Format cameras such as the Canon 5D and the Nikon D800 use the same focal length lenses as their film counterparts.

1.2

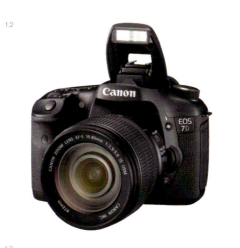

1.3

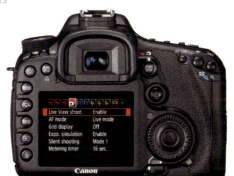

1.4

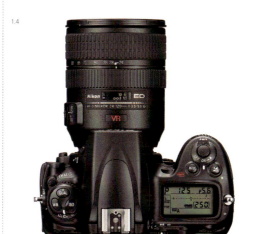

1.2
Good quality DSLRs, such as the Canon 7D, have a rugged body and weatherproof seals.

1.3
The rear LCD screen is used for defining image quality and capture settings, and for previewing images before and after shooting.

1.4
The top LCD screen is used for setting exposure controls, such as aperture, shutter speed and ISO.

COMPACT CAMERAS

Compact cameras are a trade-off between versatility and portability. Although many compact cameras boast high-resolution capture, cheaper models employ tiny image sensors that create noisy, poor quality results when compared to DSLRs. The very best compacts that produce the highest quality images are at least twice the cost of a comparable DSLR.

SMARTPHONES

Many smartphones have a digital camera function offering high-resolution capture. Like most digital compacts, achieving accurate exposure, pin-sharp focus and precise depth-of-field effects is not simple. If it's not a one-gadget-does-all that you're after, then an advanced compact built with the same resolution gives more controls and better quality prints.

ADVANCED DIGITAL COMPACT

Designed to present the keen photographer with advanced controls and functions, the top price compact has a better build quality, better on-board software than cheaper models and you can use clip-on lens attachments or a limited range of different lenses. With an interface for attaching external flash units and high-capacity memory cards, better digital compacts often use innovative viewing systems, such as a rotating LCD preview screen or a through-the-lens finder, for a more accurate composition.

1.5
Pocket-sized cameras are great for shooting subjects such as travel, people and landscape, but they usually have limited manual settings for the precise control of shutter speed and aperture values.

1.5

1.6

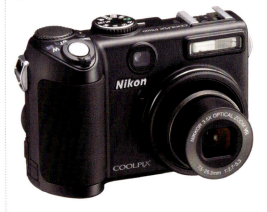

1.7a–1.7b

A step up from an advanced compact, mirrorless cameras as designed by Olympus and Panasonic Lumix use a bigger Micro Four Thirds image sensor. These cameras have electronic viewfinders, and facilitate a wider range of interchangeable lenses than other compact camera types.

1.7a

1.7b

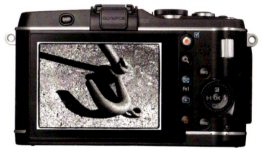

1.6

The Nikon advanced digital compact affords more creative play than budget models.

1.8

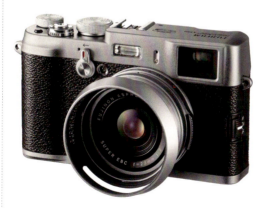

1.8

The rangefinder compact is the most advanced form of compact camera; it's made by Fuji and others. A special focusing system called a 'coupled rangefinder' blends two 'ghosted' versions of the image together to achieve focus. This compact has the functionality of a good quality DSLR combined with the quick operation of a professional film camera.

MEDIUM FORMAT CAMERAS

High-resolution cameras are designed for professional use and are based on the medium format camera system. Used by advertising, fashion and editorial photographers, these cameras can record the finest detail and make the biggest prints.

There are fewer types of medium format cameras than there are DSLRs. Produced by PhaseOne, Hasselblad and Mamiya, medium format cameras use a wide range of interchangeable lenses, winders and viewers. Many professional photographers use medium format digital cameras and the latest models offer near-continuous shooting with little or no delay, and at the opposite end of the scale, very long time exposures.

DIGITAL BACKS
In addition to dedicated camera kits, high-resolution digital backs are also available and work by clipping onto the body of a medium format film camera or large format kit, providing a seamless transition to shooting digital files. At least five times the price of a professional medium format camera kit, digital backs can capture up to 80 megapixels of data, or 120 Mb files, more than three times the resolution of a professional DSLR. High-resolution digital backs can also be used in conjunction with large-format camera systems favoured by architectural photographers.

1.9a

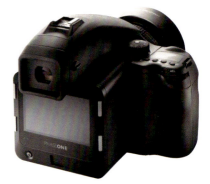

1.9b

1.10

1.9a–1.9b

Unlike the DSLR, the medium format camera uses a larger image sensor and can produce highly detailed images capable of greater enlargement.

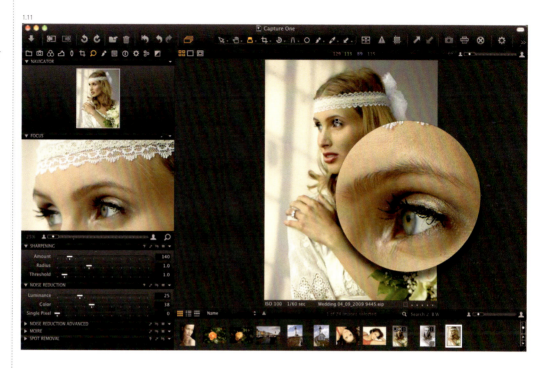

1.11

1.10

Digital backs create image files in excess of 80 megapixels, but are expensive.

1.11

Capture One software is a favourite editing application in the professional field and is designed to extract the maximum quality images from specific sensors.

CAPTURE SOFTWARE

Most digital backs are supplied with professional software to improve your workflow. Essential for high-volume catalogue or product photography, capture software can process, label and reference work as it's produced, saving later time-consuming editing. File format options follow the standard TIFF and RAW variants, so work can be captured, archived and processed at maximum quality.

TETHERED SHOOTING

Both Lightroom and Capture One offer an alternative kind of editing environment for studio photographers. During the shoot, the camera is connected, or tethered, to a desktop computer and image files are transferred immediately into editing software. Tethered shooting applications also let you control camera functions from your PC, including focus and aperture settings, so that you can have precise control.

LENSES

If you understand exactly how a lens works, you'll take much better photographs and be able to pre-visualize the result before pressing the shutter.

Lenses are primarily bought for their focal length, which is described in a single measurement such as 28mm, or as a range such as 17–55mm. Focal lengths tell you how wide or narrow a scene you can capture. The lens closest to simulating our own human angle of vision is called a standard lens and typically has a focal length of 50mm in full-frame cameras. Wide-angle lenses have shorter focal lengths than standards, such as 28mm and telephoto lenses have longer lengths such as 100mm. It's important to remember that focal length is proportional to your sensor, so a wide angle for an APS-C small sensor camera has a shorter focal length than an equivalent for an FX/ Full Frame. Lenses are never interchangeable between different brands, such as Nikon and Canon, and can rarely be used on both small and full-frame sensor bodies.

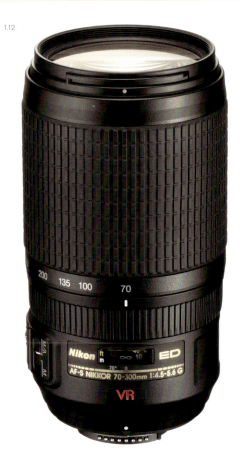

1.12
Many DSLR cameras are sold with kit lenses, typically mid-range zooms with slow maximum apertures of f4, or even different maximum apertures at either ends of the zoom range, such as this Nikon lens expressed as 70–300 f4.5–f5.6. Kit lenses tend to be much less rugged, with a slightly inferior optical quality compared to more expensive, faster lenses.

APERTURE, F NUMBERS AND STOPS

Inside the lens is the aperture diaphragm, which is used to regulate how much light passes on to the sensor. Like the pupil in your eye, bigger apertures are used to let in more light in dim conditions and smaller apertures let in less when it's too bright. Aperture values are described in f numbers, such as f2.8 and f16 and are always arranged in the same numerical sequence of 2.8, 4, 5.6, 8, 11, 16 and 22. If you increase the aperture value by one step along this sequence, the amount of light hitting the sensor is doubled. If you decrease the value by one step, the amount of light is halved. F numbers also influence your depth of field.

1.14

Aperture values are usually selected on the top LCD menu on the camera body, but some older lenses still have a moveable ring for manually setting aperture values. Each shift up and down on this ring is recognized by a click stop. 'Stop' is a term used by professional photographers to describe precise amounts of change in exposure, lighting and editing.

1.13

Lenses with maximum apertures of f1.8 or f2.8 are known as 'fast' lenses, as they allow in more light in dimmer conditions; they tend to be expensive. Cheaper lenses with maximum apertures of f4 or f5.6 are referred to as 'slow' lenses and are much less versatile. This example is a super fast f1.4 lens.

1.13

1.14

18

FOCAL LENGTH

1.15 a–1.15c

a. Telephoto lens
b. Standard lens
c. Wide-angle lens

The amount of a scene you can see through your lens is described by its focal length. A telephoto lens is a useful tool for making far away subjects bigger in the frame, much like a telescope does. Unlike zoom lenses, telephoto lenses have fixed focal lengths, such as 180mm.

A long telephoto lens is very useful for sports and action that the photographer can't get close to. Wide-angle lenses are best used when shooting in confined spaces indoors. They have the opposite effect of telephoto lenses by pushing your subjects away from you. If you use a wide-angle lens in normal situations, your subjects will look tiny when printed. A zoom lens gives you more freedom to frame near and far away subjects, without moving your own position. A zoom lens such as a 17–80mm is a wide-angle, a standard and a telephoto rolled into one and is much less to carry in your bag.

Macro is another word for close-up photography. All lenses have minimum focusing distances that prevent you from focusing on nearby things, but a macro lens lets you get close to smaller objects to capture the tiniest of details.

1.15a

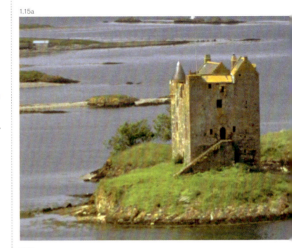

1.15b

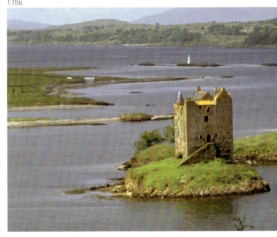

1.15c

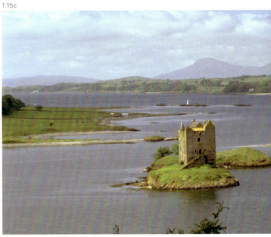

VIBRATION REDUCTION (VR) AND IMAGE STABILIZATION

Good quality and more expensive lenses are supplied with additional functions that minimize the effects of camera shake.

LENS COATINGS AND CARE

Good quality camera lenses are manufactured with a special anti-reflective coating designed to help improve image quality. This multicoating improves both contrast and colour reproduction, yet is easily damaged by grease from fingers. Once smeared with a tiny amount of natural oil from your skin, the performance of a lens drops dramatically, creating flat contrast images with washed out colours. If your lens does get marked, clean it only with special lens cleaning tissues, or for more serious cases, an alcohol-free spectacle wipe. Tiny specks of dust, sand and human hair will also reduce your image sharpness and this should only be removed by using a blower brush (available from all photographic retailers) or a soft artists' paintbrush. Any grit or sand that comes into contact with your lens can potentially etch a permanent scratch and will ruin it forever.

PROFESSIONAL TIP

Fast autofocus
Autofocus lenses can be focused manually, and the fastest kinds of lens to focus are equipped with an internal motor rather than a mechanism housed in the camera body. Ultrasonic motor lenses are fastest and nearly silent in operation.

LENS TYPES

Good lenses do not come cheaply, but they are an essential part of a photographer's kit enabling them to respond to a wide range of shooting scenarios.

1.16
Henry Lowther has used a telephoto lens combined with a shallow depth of field to help blur backgrounds and emphasize the person.

1.17

1.17
Wide-angle lenses such as 17mm, 24mm or 28mm are best employed in confined spaces or in situations when you are forced into a position very close to your intended subject.

1.16

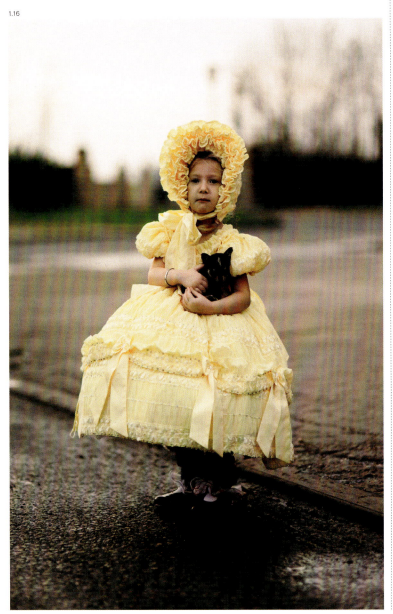

1.18

1.18
Prime lenses capture the finest subject detail of all camera lenses.

1.19
Prime lenses have a fixed focal length, such as 35mm, 50mm or 300mm and usually have wide and fast maximum apertures like this Canon 14mm f2.8.

1.19

1.20
With portrait photography, wide-angle distortion causes facial features to appear pulled in all directions, leaving an unflattering result.

1.21
If you are not holding your camera in a level position, the wide-angle lens will exaggerate any vertical or horizontal lines into converging triangles.

1.20

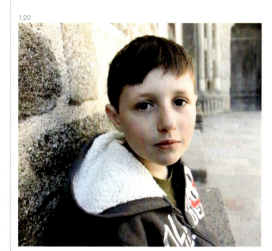

1.21

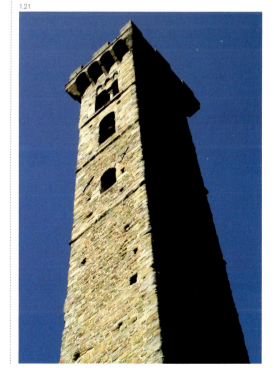

THE PRIME LENS

Many of the world's best photographers use prime lenses rather than zoom lenses, but have to move their own shooting position to frame their subjects. Prime lenses are available from the specialist wide-angle fish eyes to the ultra-long telephoto lens for sports and action photography.

THE WIDE-ANGLE LENS

Wide angles have the visual effect of pushing a subject away from you and can be a very useful tool if you need to photograph an object to show its entire perimeter edges. With this versatility comes an unfortunate compromise with shape distortion. This can be a very effective way to make graphic and dynamic images out of mundane subjects, but much less useful for making a faithful documentary image. With portrait photography, too, this distortion will cause facial features to become pulled in all directions, leaving a very unflattering result.

Avoid using the wide angle in everyday situations because your subjects will be pushed away from you and appear much smaller and less recognizable in the final print. For photojournalists the wider 24mm is a well-established favourite, pushing the subject away from the photographer when shooting in confined situations compared with the 28mm. Cheaper wide-angle lenses create barrel distortion and will never be able to capture parallel lines faithfully.

1.22

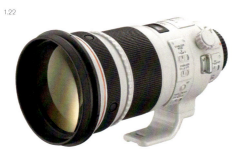

1.22
The telephoto lens can be described as anything with a focal length greater than a standard lens.

1.23
This picture of a diver creates a frozen image that we'd never see in real time.

THE TELEPHOTO LENS

A telephoto lens is most useful for shooting distant subjects and cropping out unwanted peripheral detail. Many professional photographers have a telephoto lens as an essential part of their camera kit. In addition to travel, sports and architectural photography, the telephoto is extremely useful for portrait photography as it creates less distortion than a wide-angle lens.

Most photographs on fashion magazine covers are taken with a long telephoto lens, as an effect called 'foreshortening' creates a very flattering result. Telephoto lenses are physically longer than standard or wide-angle lenses and more like the shape of a telescope. With this extra increase in size comes extra weight and potential problems with the photographer's balance. Focused on a tiny object in the distance, an extended telephoto lens will start to wobble, making it essential to grip the camera steady or use an extra support, such as a monopod or tripod.

For long lens work, you should use a minimum shutter speed of 1/250s to avoid the unwanted effects of camera shake. The most demanding of all subjects to photograph is a fast-moving spectator sport, like football or cricket, as there's little or no time to focus and the subject keeps moving out of frame. Many horse racing action shots are shot by photographers who pre-focus on a fixed point on the course, then wait for the horses to enter the zone before pressing the shutter.

1.23

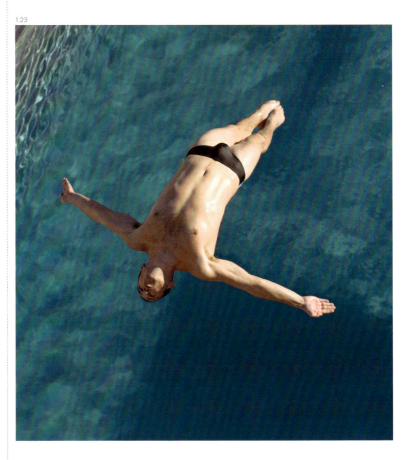

1.24

THE ZOOM LENS

A zoom lens lets a photographer have the freedom to frame subjects at different distances without altering shooting position. At the 28mm end of the lens, a wide angle of view is created for shooting cramped circumstances. At the 105mm, or telephoto end, the subject is pulled closer like a telescope; this is useful for filling the frame with strong shapes. Many mid-price zooms have a disappointing maximum aperture, such as f4, which is much less useful than a prime lens at f2.8. In shooting terms, this can stop photography in low light conditions and will not produce such dramatic shallow depth of field effects. This maximum aperture value is very rarely constant across the entire zooms' range, often changing from f4 at the wide-angle end to f5.6 at the telephoto end.

Zoom lenses that have an extreme range from wide angle to long telephoto, such as 28–300mm, have a lesser optical quality than zoom lenses with shorter ranges such as 24–55 mm or 35–80mm.

1.24
Zooms are multipurpose lenses that are designed with a variable focal length such as 28–70mm.

1.25
With foreshortening, the physical distances between near and far elements become much more compressed with a telephoto and is the exact opposite of the wide-angle effect.

1.25

1.26a

1.26b

1.26c

1.26a–1.26c
Zoom lenses provide you with a great opportunity to experiment with different compositions while standing in the same place. These three variations were captured with the zoom lens on widest, mid-range and longest focal length settings.

24

MACRO OR CLOSE-UP LENS

Macro is another word for close-up photography. Not all cameras let you focus on very nearby things, but those with macro lenses let you get close to small objects like flowers. When close focusing, you are more prone to camera shake, so a steady hand is called for.

Professional wildlife photographers opt for a purpose-built macro lens, specially designed for ultra close-up work without producing distortion. Unlike a mid-range zoom lens fitted with an additional macro function, these kinds of professional lenses are fixed focus, usually around the 50–100mm focal length and produce images that can be greatly enlarged without loss of sharpness. For even greater magnification, an additional bellows kit can be fitted between camera body and lens, allowing the subject to be recorded life-size on the sensor.

1.27

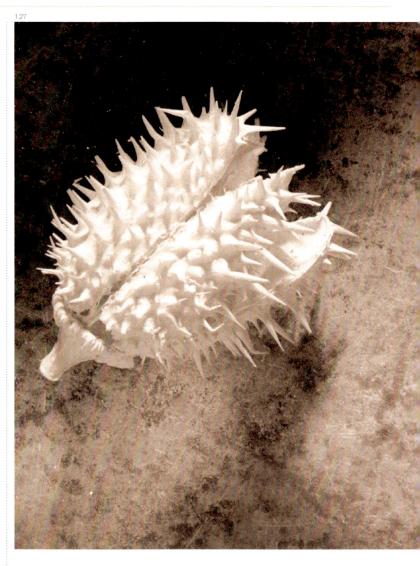

1.27
The set for this still-life image was no bigger than a paperback book, so a special macro lens was used to focus closer than would be possible with most lenses.

1.28

1.28
Vignetting occurs when
darkness encroaches
from the four corners of
the image, usually caused
by using the wrong lens
hood or too many filters
on the lens.

HOODS, FILTERS AND VIGNETTING

Never use a lens without first fitting the
maker's recommended lens hood, which
is designed to improve contrast and remove
unwanted glare. All lenses have a screw
thread at the front to allow filters to be
attached. Rarely do different lenses share
the same thread, so you won't be able to swap
filters between them. Never attach more than
one filter to your lens and never be tempted
to attach a cheaper lens shade that wasn't
designed specifically for your lens.

　All lenses 'project' a circular image onto
your rectangular sensor, which crops off
the unwanted edges. Strange black corners
appearing around your photographs are
caused by the use of an incorrect lens shade
or by too many filters. This effect is called
'vignetting' and results from a light fall-off
caused by a physical barrier placed in the
pathway of light at the corners of your image.
Although clearly visible on the end result,
vignetted corners are notoriously difficult to
see in the camera viewfinder, so results can be
unexpected. Vignetting commonly occurs in
zoom lenses at the wide-angle end, but far less
with telephoto.

USING ADOBE PHOTOSHOP

Before you can use Photoshop, you will need a computer and a reliable monitor. Accurate photo-editing and printing are entirely dependent on a good quality monitor, and like camera lenses, make your job of selecting and editing that much easier.

COMPUTERS
Your choice of computer can range from a laptop to an all-in-one computer, such as the iMac, to the ultimate in colour control, an Apple Mac Pro workstation. With this kind of set-up, you can use a wide range of monitors; install additional memory and hard drives. Installing extra memory or additional hard drives is a straightforward process for confident do-it-yourself enthusiasts without the need for specialist tools.

MONITORS
Aim for a monitor with a contrast ratio of 600:1 or more and a brightness of 300 cd/m2 or more. Every display is compromised by ambient room light and distracting background colours. However, your viewing conditions are easily improved by adding a wrap-around hood or a low-tech screen in a neutral colour.

INTRODUCTION TO PHOTOSHOP
Adobe Photoshop provides a sophisticated editing environment for photographers, new media creatives and graphics professionals alike.

Most professional photographers shoot RAW files in camera to create the best image quality, but this can be hampered if you don't choose the right editing tools or sequence. Adobe Photoshop provides a two-step process for processing RAW files: first they must be opened and edited in the Adobe Camera Raw plug-in where technical edge-to-edge edits are made, then the creative editing takes place in Photoshop.

ADOBE CAMERA RAW PLUG-IN AND PHOTOSHOP
The ACR plug-in is issued with all versions of Photoshop and Photoshop Elements. The plug-in is updated on a regular basis to accommodate the ever-increasing number of new cameras that appear on the market. However, newer versions of ACR do not necessarily work with legacy versions of Photoshop and Elements. Unlike Lightroom, you have to edit each file independently in ACR, and as a separate step prior to the file opening in Photoshop. Most users find this intermediary step a tricky one, not knowing what to edit in ACR or what to leave to do in Photoshop later on.

GO NON-DESTRUCTIVE WITH ADJUSTMENT LAYERS
If you apply Photoshop edits as Adjustment layers, you can keep the image in a state of permanent flux. This way, there's no need to make a long sequence of correct edits, as you can go back and change earlier commands until you've created the desired effect. In simple terms, non-destructive processing describes a wide range of methods by which original image data is protected throughout an editing sequence and not overwritten with each command. When a digital image is first opened, an image editor converts the complex strings of pixel data into colours, shapes and lines. If the original file is never modified or re-saved, this original data is left intact.

1.29

For maximum RAW file flexibility, you can create a two-way link between Photoshop and the Camera Raw plug-in. Shift click the Open command in the Camera Raw to launch the image into Photoshop as a Smart Object. Now you can edit in Photoshop and also return your image to Camera Raw by double-clicking the Smart Object layer icon. This example image is processed in ACR, but launched into Photoshop as a Smart Object.

1.30

Adjustment layers are shown on the far right-hand panel.

Non-destructive editing

A digital file can deteriorate when the cumulative effect of editing stacks up. At best, original digital files can be preserved as a kind of latent digital image, with the ability to return and re-process the raw data created at the sensor. At worse, files can be overcooked and damaged beyond repair.

1.29

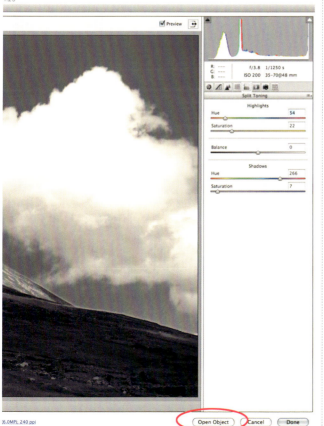

1.30

IMAGE-EDITING SOFTWARE: ADOBE LIGHTROOM

Lightroom is a combination of browser, catalogue and RAW file image editor that allows you to organize and develop your images in a one-stop non-destructive working environment. Unlike Photoshop, it's been developed purely for photographers and is a much easier application to learn for a beginner.

WHAT IS IT?

Unlike Photoshop, Lightroom doesn't provide masks, layers or other photomontage tools, but focuses on the nuts and bolts of straight image processing. For professional photographers who use very little of Photoshop's gigantic functionality, Lightroom offers a faster and more targeted set of controls for straight photography. Unlike other image-editing packages, commands and changes made to an image in Lightroom do not become embedded in the source file, but are kept separate in a Catalogue file, so there's no need to use the Save command and editing decisions remain fluid forever.

Lightroom is accessed through different functional panels called 'Modules': Library, Develop, Map, Book, Slideshow, Print and Web.

THE LIBRARY MODULE

After importing your files, you can view your entire shoot in the Library module. Here, you can review which images to work with further, delete unsuccessful ones or move them into a simple sequence.

Alongside the different view options are quick reference panels and a Quick Develop panel, should you just want to apply basic image edits to individual, or groups of, images.

THE DEVELOP MODULE

Core image editing occurs in the Develop module, as shown in image 1.31, where you can access the full range of controls to process your image in a non-destructive manner. On the right-hand side of the desktop is a panel of controls, starting with the Basic collection of colour, exposure and brightness/contrast options. Exposure can be altered here, too, via a combination of Histogram sliders and Curves commands.

There are three areas that you can edit: highlight, midtone and shadow and these can be altered by typing directly in the text box or by pulling the compression slider to reduce or pushing the slider to increase.

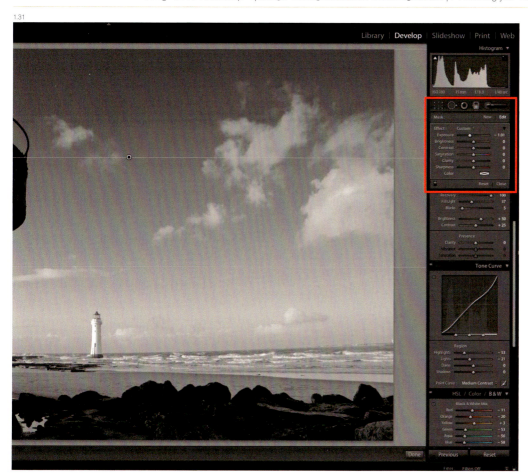

1.31

Working with the
Develop module.

CROP AND STRAIGHTEN MODULE

Next is the intuitive Crop and Straighten module, which permits cropping to a better composition and fixing slanted horizons. All commands made in this module are reversible, so a crop is not made forever, with cropped out pixels remaining 'hidden' rather than actually discarded.

Moving down the edit sequence, the next panel of commands are the individual colour controls allowing you to remix varying amounts of original colours and prepare a monochrome conversion.

Next up are the Detail and Lens Corrections dialogs, which are aimed at sharpening and correcting lens distortion.

If you shoot with newer Canon or Nikon lenses, Lightroom will recognize your lens and correct any typical distortion or vignetting. Sharpening is also available in the Print Module, selected just before output.

The final control is called Camera Calibration, a very useful tool for linking in your own camera profile or creating a setting that counteracts the capture tendencies of your image sensor.

EXPORTING

Once an image is edited to your liking, you can do one of two things. Remembering that Lightroom saves versions of edits rather than actual unique files, you can chose to export as a totally new file or leave the edit in place. With the latter option, the edit can be removed at any time, simply by pressing the Reset button in the develop module. When a finished version of your file is made, you need only export the image to send to your client, remote printing service or website. There's no need to export files if printing directly from your desktop.

BOOK MODULE

The Book module allows you to create layouts for on-demand book printer's Blurb without the need to learn another application. You can group images together in a subset of Library called a Smart Collection. This is a useful tool if you are creating a photo book.

SOFT-PROOFING

1.32

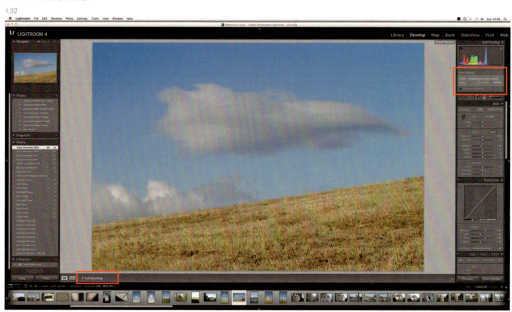

1.32
Lightroom also provides a soft-proofing function, as shown in this example, for simulating the appearance of your image on a chosen printer, ink and paper combination. Easy to switch on and even easier to edit out of gamut colours back into range. It's available in the Develop module, so your editing is more focused on the end result. Soft proofing effectively helps you see how your edits impact on the final print, giving you the chance to change before committing to a sheet of expensive printing paper.

1.33

1.33
The Map module is Google Maps built into a Lightroom window, which obtains GPS data from your image file if you've used a GPS device, or can be used to retro tag your work to your shooting location. Mapping is another way of cataloguing your work; shown here is an image that has been linked to its original shooting location.

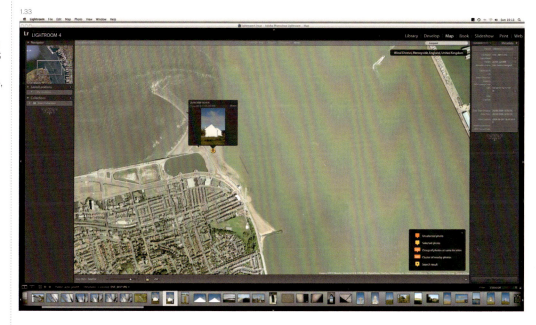

ARCHIVING YOUR WORK

Get into the habit of managing your growing image library and you won't waste valuable time searching for images from an old shoot.

ARCHIVING ESSENTIALS

Each time we shoot a new batch of images with our DSLR, files are created and named with unrecognizable file names such as 034. CR2 or DSC083.jpg. It is impractical to rename hundreds of individual files with memorable titles, so a more time efficient way is to catalogue and view your files using a specialist software application.

In addition to its image-editing functions, Adobe Lightroom is used by professional photographers as a sophisticated browser and archiving application. You can easily point Lightroom to any existing folder of images on your hard drive or straight from your digital camera through a simple File>Import command.

STEP 1: TRANSFERRING FILES FROM YOUR CAMERA

Start by creating a single folder or directory on your chosen storage device where all your images will reside, such as Image Library. Next, create a new empty folder for each shoot. The simplest naming protocol is to use the name of the subject, or location – followed by the date. Once created, transfer your files from your DSLR.

STEP 2: IMPORT YOUR FILES INTO ADOBE LIGHTROOM

In Lightroom, import your files at the current location, choosing the Add command, as shown to import without creating new copies. This command automatically creates a set of thumbnail images that sit within Lightroom.

STEP 3: VIEW YOUR SHOOT

Once imported, your shoot is referenced by the folder name you created, as shown. Each time you import a named folder of images, a permanent reference is created in Lightroom's Catalog panel (see image 1.34). Click on each folder name to see the contents of each shoot. As long as you don't move or rename your original files, the link remains permanent, providing a fast and intuitive way of viewing your work.

STEP 4: CREATING EDITED SUBSETS

An additional benefit of editing with Lightroom is its ability to arrange images into different groupings called Collections (see image 1.35). Collections are best thought of as a compilation, where images drawn from other shoot folders are placed into a special set. Best of all, your files are never duplicated or moved from their original location when incorporated into a Collection; instead, a new link is created to the original file. When working on a photographic assignment, create a Collection to house your final images for printing out, or your first edit for further consideration.

In this example, I've created a Collection for a set of images that I'm using to create a Slideshow. Thirty-three images were added to this Collection from different folders and are now in a single place where I can review my selection.

1.34

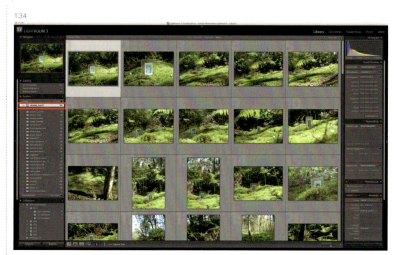

1.35

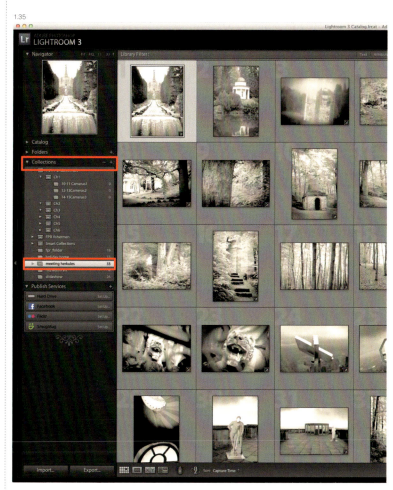

Keywording

Lightroom is useful if you want to divide a large shoot into different subjects and re-catalogue files with new names or a different order. For those building up very large catalogues, you can also add keywords to individual or groups of images here, too, thereby making it easier to search and retrieve your files later on.

DATA STORAGE

Photographers typically ignore the risk of data loss by committing their precious files to a single storage source.

PLANNING YOUR GROWING STORAGE REQUIREMENTS

Photographers spread their irreplaceable image files across multiple disks and drives, making quick retrieval a real time wasting exercise. With unsorted image files crammed onto unlabelled CDs, DVD disks, pen drives, redundant computers and numerous separate external hard drives, we all risk losing our precious data, together with our sanity. A much better idea is to invest in a single desktop storage system that can be expanded as you develop your own library of digital images. All your images are stored in the one place making it easy to retrieve, catalogue and archive your work.

OPTION 1: HIGH-CAPACITY EXTERNAL HARD DRIVES

An easy way of upgrading the available storage space on your workstation is to buy an external hard drive (see image 1.36). Although more expensive than an internal hard drive with the same capacity, desktop drives are easily connected through the computer's USB or FireWire ports. Drives such as these offer a convenient way to transport large volumes of images between different workstations, providing the unit is carefully handled in transit and connecting plugs are not forcibly inserted. The downside is that if the disk fails, you'll lose everything. LaCie external hard drives can be linked together to create substantial storage volumes.

OPTION 2: REMOTE STORAGE

If you've got a high-speed broadband connection, then you can send your files to a remote storage service, such as Apple's iCloud. There's no need for extra computer hardware and you can retrieve and share files easily from any Internet enabled device. The downside is the ongoing subscription cost, which will increase as you increase your need for storage.

1.36

OPTION 3: USB POWERED DRIVES

With available capacities now measured in terabytes, the humble USB-powered portable hard drive can provide a very useful backup and portable storage facility (see image 1.37). The LaCie Rugged drive draws power from the host computer and, with no moving internal parts, is much less vulnerable to physical damage caused while in transit.

OPTION 4: RAID ARRAY SYSTEM

The Drobo is a shoebox-sized storage system that plugs into the back of your computer and is designed to accept up to four standard SATA hard drives (see image 1.38). Unlike other RAID systems, the Drobo can be fitted with recycled hard drives from an older workstation, brand new drives or a combination of the two.

Unlike a single-drive storage system, the Drobo spreads your data across two, three or four drives depending on your budget and storage requirements. If one drive fails, then your data is still safe. There's no settings, options or configurations to learn, the unit is simply plugged in and ready to use. Fitted with super fast Firewire 800 and USB 2 ports, the Drobo is easily used as a primary storage device for a single user rather than just a backup insurance drive. You can store large volumes of image files easily, accessing high-resolution files in Photoshop and Lightroom without any noticeable reading or writing delay. The Drobo can also be shared across a network with the addition of a DroboShare unit, ideal if you have more than one computer in your set-up.

The benefit of the Drobo for many photographers is it's a pay-as-you-grow design, so you can add extra capacity when needed without investing in an entirely new system.

1.37

1.38

PORTS AND CONNECTING CABLES

Most storage peripherals are designed to transfer data at high speed using either USB or FireWire connections. Some devices, like the LaCie desktop hard drive, can use both. High speed data ports are still evolving, with FireWire (IE1394) and USB 3.0 common across professional workstations. There are many different variations of FireWire connections, so it's important to do your research before buying new hardware.

MANAGING COLOUR

Taking charge of colour is a critically important part of professional practice.

COLOUR MANAGEMENT ESSENTIALS

Practical colour management is simple and straightforward, but needs to be set-up correctly before you start to shoot, edit and print. Colour management is no more complicated than ensuring you are shooting and editing in the same colour palette and setting up your workstation properly. Done badly or not at all, you'll experience unexpected results and waste valuable time and money.

WHAT IS A COLOUR SPACE?

In today's digital world there are three commonly used colour palettes, or colour spaces: sRGB, Adobe RGB (1998) and ProPhoto. sRGB has the smallest palette, ProPhoto the largest, but is still an emerging standard and Adobe (1998) is the most commonly used by photo professionals. Although each individual colour in a digital image is drawn from a palette of 16.7 million variations and stored as a unique string of numbers, the same numbers may not produce the same colour when translated across different colour spaces.

In digital photography, no universal colour palette exists, but most professionals and service providers use Adobe RGB (1998). Shooting with a smaller palette, such as sRGB, means that fewer saturated colours are created in your image file.

1.39
Colour spaces, such as ProPhoto, Adobe RGB and sRGB, each show a different palette of colour.

1.39

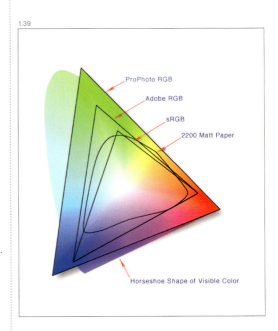

STEP 1: SET UP YOUR DSLR COLOUR PALETTE

In your DSLR's settings menu, scroll to the Workspace, Color Space, or Color Mode option. Set your palette with the Adobe RGB (1998) as shown (see image 1.40).

STEP 2: SYNCHRONIZE YOUR IMAGE EDITOR

Lightroom by default is set to edit with the largest colour space, ProPhoto, which encompasses all other colour palettes without adverse effects. Adobe Photoshop, however, needs to be synchronized through its Color Settings menu (see image 1.41). In Photoshop's Color Settings panel, set your RGB Working Spaces to Adobe RGB (1998) as shown.

STEP 3: CALIBRATE YOUR MONITOR

New monitors are usually set too bright, too blue and with too much contrast. If left in these factory settings, you'll be over editing your image files to compensate and your prints could emerge too dark, too yellow and too flat.

Calibration is the process by which a monitor is set-up to display a uniform brightness and contrast, together with a neutral colour balance. The most effective way to do this is to use a purpose-made monitor profiling device. The profiler is plugged into your PC and automatically corrects the current monitor settings before creating and installing a permanent settings file in your operating system. This tiny file, called a 'monitor profile', is then used as the default setting each time your PC is switched on, or if you accidentally change your viewing conditions with the hardware dials.

No experience of colour calibration is required to use one of these devices. Once placed on the surface of the monitor, the light-sensitive profiler responds to a succession of coloured patches displayed on the screen, taking about ten minutes from start to finish. Many photographers re-profile their monitors every three months to ensure an accurate colour environment.

1.40

1.41

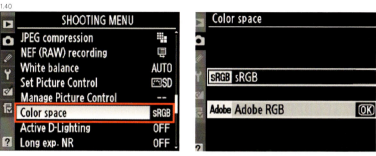

1.42–1.43

The quality of light from a studio flash unit can be changed by attaching different modifying heads, such as an umbrella or softbox.

STUDIO FLASH

Unlike the unpredictable nature of ambient light on location, shooting with studio flash has a certainty about it.

With studio flash, there's no waiting around for the right kind of light effect or struggling with a wealth of distractions. With an external flash unit set-up, you're the boss and you alone can carefully match the character of your sitter to a photographic style and atmosphere. Moving up from a basic camera and camera-bound flash unit kit to a versatile lighting kit will give you more creative power, but at a price. For this review, we've tried the latest Elinchrom battery-powered lighting kit and created four different shots, all using a different lighting technique.

1.42

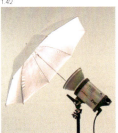

1.43

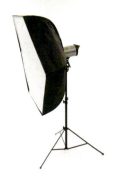

HARDWARE ESSENTIALS

Flash kits are supplied in two forms: the cheaper individual monoblocs and the more expensive powerpack units. Monobloc lights have their own built-in power supply and can work independently from other light sources, sometimes at a great distance. Powerpack flash kits use unpowered lightweight heads, which are plugged into a single mains-powered or battery pack. Both types are manufactured in different strengths, measured in joules, with a basic 400-500J head offering enough output for all types of studio portrait. Weaker strengths, such as 250J, need to be used closer to your subject and may not allow you to shoot using smaller aperture values, such as f16. The most expensive high-powered lights, such as 1200J, offer bright light intensity over a greater distance, ultra-fast recycling time and stepless power output.

1.44

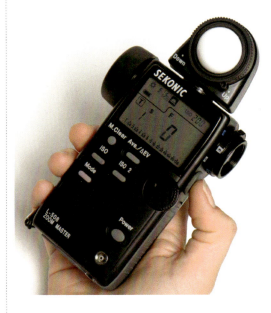

FLASH METER

At the heart of a flash exposure calculation is the handheld flash meter (see image 1.44). Unlike shooting on location with continuous daylight, your camera meter doesn't respond to the fast burst of light produced by studio flash, so an independent meter is used instead. With the camera set on Manual exposure mode, the flash meter is used to determine the aperture value required for making an accurate exposure. Most bursts of studio flash are ultra quick, so there's no need to take account of the ambient light and the shutter speed, so the shutter speed setting can stay constant.

Set your camera to 1/60th of a second and leave it there. The flash meter works by detecting light levels through a fixed white dome called an 'invercone', which must not be obstructed. It's only necessary to take a reading at the start of the shoot, or whenever you change the position of your light or sitter. Positioned as close to the subject with the invercone pointing at the camera lens rather than the light, the flash meter triggers the burst of flash and creates an aperture value reading. Many better flash meters are also ambient light meters and can be used on location to determine difficult lighting situations that would ordinarily fool the camera meter.

MODELLING LIGHTS

Many photographers use a basic two head kit for studio portraits, but it is possible to make very creative effects with a single head and a reflector. Unlike hot shoe flashguns, which fire on and off without a preview, studio lights are fitted with an extra light bulb called a 'modelling lamp'. The modelling lamp stays on all the time and can help you to judge the quality and atmosphere of your lighting style. This lamp switches off the moment the flash fires, so it has no bearing on exposure. Throughout shooting, the flash unit is connected to the camera via a synchronization cable attached to the camera or with an infrared trigger system allowing you more flexibility.

1.45
Light output is controlled by independent stepless sliders for both flash tube and modelling light.

1.45

1.46
A softer and more flattering quality of light is achieved when using a softbox modifier, although slight shadows still remain.

1.47
All flash kits are supplied with a basic cone-shaped reflector that encircles the flash head. Unmodified light like this creates harsh contrast, but picks up much more texture and shows detail sharply.

ASSIGNMENT: UNIQUE APPROACHES

1.48
Despite his choice of camera, Killip was still able to capture fleeting moments.

Sometimes the most memorable images are created by photographers who have deliberately chosen unconventional equipment to deliver their projects.

THE BRIEF
Your task is to research the following four photographers and find out how the very tools they employed have had a profound effect on their results.

1 Research the photographer Chris Killip and his project *In Flagrante* (and book of the same name). Search for examples of images from this piece of work, make a selection of them and make some notes on how you think the photographer took the pictures.

Next, dig a little deeper and find out what kind of camera he used.

a How did Killip's choice of camera moderate his response to his subjects?
b How do you think his subjects reacted to this?

2 Research Daido Moriyama and his book *71-NY*. Search for examples of images from this book, then speculate how Moriyama employs his camera. In your research, try and unearth what the artist thinks about conventional shooting techniques and how he shoots his pictures.

a What kind of visual statement does Moriyama's technique deliver?
b How is this different to another street photographer, such as Lee Friedlander?

3 Richard Avedon's project *In the American West* crystallizes many iconic portraits of workers. For the project, Avedon used a very special camera, which delivered high-resolution negatives (and therefore giant prints), but prevented him from using one fundamental photographic technique. Search out a selection of images from the project and then research what camera he employed and what he wasn't able to do when making each exposure.

a What impact did Avedon's choice of camera have on the final prints?
b How did the relationship between photographer and subject change as a result of his camera choice?

4 The work of Thomas Demand sits between sculpture and photography, observed and imagined, truth and fiction. Search out a selection of his images and find out how they were made and what Demand is compelled to create.

a What part does photography play in the process?
b Why is equipment choice less important in Demand's work than with Andreas Gursky's?

1.48

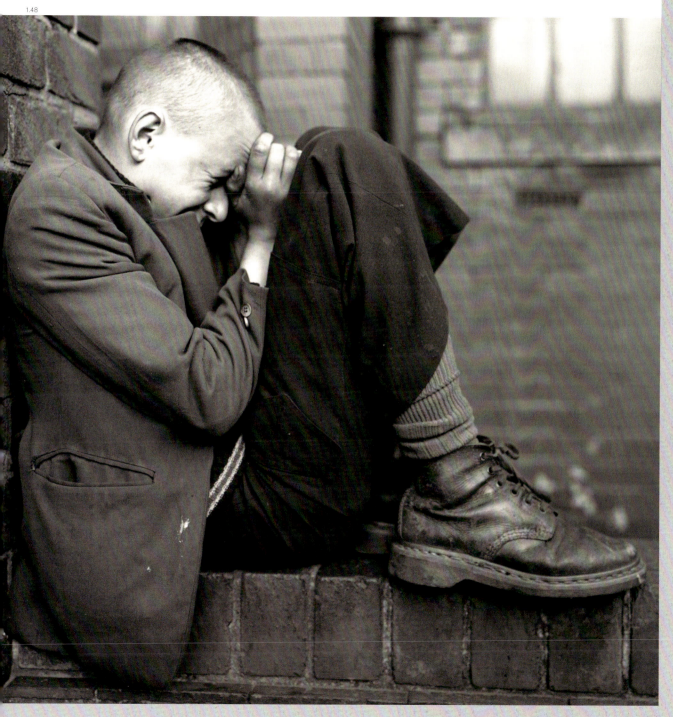

CHAPTER 2

SHOOTING SKILLS

Effective camera skills are a fundamental prerequisite of photography and should be studied in tandem with your emerging practice. Shooting skills enable you to realize your inner thoughts and concepts and help transform the subject in front of you into a compelling visual statement. Like a writer or painter, you will employ different techniques to create emphasis where it's needed and to help direct the viewer to the message or meaning embodied in the image. This chapter takes you through all the essential shooting skills for tackling a wide range of different photographic projects, from navigating the enormous number of different camera settings to exposure and depth-of-field techniques.

'One really doesn't associate a machine – a little box with glass in it – with the personal imprint of the operator, but it is there, and it's a kind of magic, inexplicable quality.'
Walker Evans

CAMERA QUALITY SETTINGS

A DSLR camera's quality settings allow you to define the best possible image quality imposed by your choice of shooting location.

2.2
Some DSLRs allow you to shoot with a different aspect ratio, such as 3:2 or 16:9, but this has an impact on your final print shape.

2.1

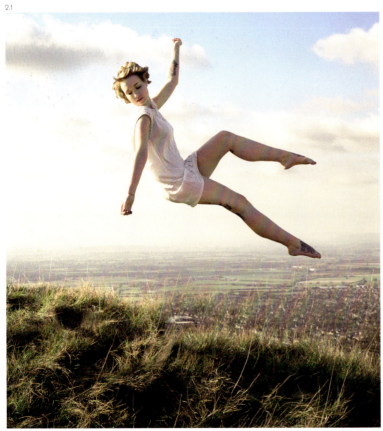

2.1
Sally Rose McCormack's unexpected image captures a surreal moment in mid-air.

2.2

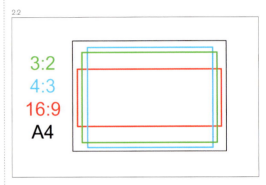

ISO

ISO is a term used to indicate the light sensitivity of your sensor. Digital sensors are manufactured to work successfully under a wide variety of light conditions. Best quality images are created by using the lowest ISO value available, such as ISO 100. ISO speeds follow a standard scale: 100, 200, 400, 800, 1600, 3200, 6400 respectively. As each of these values double, the sensor requires only half the amount of light to work effectively. When the ISO value is halved, for example from 400 to 200, then twice the amount of light is necessary. Low values, such as ISO 100, are selected when shooting in bright conditions; higher values such as ISO 800 are used in dim lighting.

2.3

2.3

SLRs have a white balance function that provides invisible colour correction caused by fluorescent tube or domestic tungsten lighting. The Auto White Balance setting is perfectly acceptable for most photographic situations, but you need to be careful it doesn't strip away atmospheric lighting effects.

2.4

ISO BY-PRODUCTS

Noise is an aspect of digital image quality, which is inextricably connected to high ISO values (see image 2.4). When high ISO settings are selected and images are shot under low lighting conditions, insufficient light causes the creation of error pixels called 'noise'. To fill in the missing data, the sensor creates a bright red or green pixel and lots of these produce a visible loss of image detail and sharpness. Noise is most visible in the shadow areas. The Auto ISO function can inadvertently create noise when you'd least expect it, so it is best left unselected.

2.5

IMAGE SIZE AND RESOLUTION

All DSLRs allow images to be created in more than one size or pixel dimension. The best quality results are created from the highest resolution files where the sensor is used to its full potential. Most settings menus describe image resolution as Large, Medium or Small. Always shoot using the Large size, as there's no advantage in shooting smaller, lower resolution files; you can make large files smaller within your image-editing application. Large files create high-resolution images, which make bigger prints.

SHARPENING

The sharpening option on a digital camera is usually available as high, normal or off options. For high-quality print work and commercial reproduction, leave the sharpening filter switched off, as this kind of edit can be applied in Photoshop as the final processing step.

EV +/-

The Exposure Value control allows the user to deliberately override the exposure set by the camera in fixed increments called 'exposure values' or 'stops'. By setting a '+' value, images will be produced slightly brighter and by setting a '-' value, slightly darker images are produced. If you have any doubts about the likelihood of an exposure working out, then a useful process is to shoot several identical images, each with a different brightness variation. This process is called 'bracketing' and is much used by professional photographers to ensure they have at least one perfect result when faced with challenging circumstances. This example shows five identical shots, with 1/3 stop differences.

COLOUR SPACE

The term colour space is best thought of as a colour palette. The advantage of working within a consistent colour space is to avoid colour change when images are transferred between different devices. Each colour space is defined by its own unique number of different colours, and if images are changed from one space to another, then some colours could convert with a far-from-exact match. The sRGB colour space is a general palette used in most digital cameras, but better cameras can be set to shoot in the Adobe RGB (1998) space, which draws upon a larger colour range.

2.5
Different camera colour spaces produce different end results.

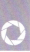

2.6a–2.6c

The bigger your pixel dimensions, the larger the print you can make.

2.7a–2.7e

Bracketing is a technique when several identical images are captured, each with a different exposure.

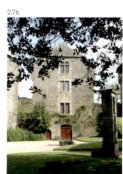

FILE FORMATS

Digital data, whether contained in
a word-processing document or digital
image file, is packaged at the point
of creation into a file type or format
of your choice.

FILE FORMATS: WHAT ARE THEY?

Like all good inventions, common file formats,
such as TIFF (Tagged Image File Format),
JPEG (Joint Photographic Experts Group) and
RAW (not an acronym, but a generic term used
to described an unprocessed image file), were
designed and launched into the world to make
workflow simpler and easier for the end user.
Your decision of which one to adopt is based
entirely on forward planning, specifically
so you can share the file with others, send it
through a network or to preserve all its original
source information. Different types of format
are identified by a three-character code called
a 'file extension', such as .jpg or .psd, which
is attached automatically at the end of your
filename to help an application recognize
compatible files.

BEST OPTION: THE RAW FILE FORMAT

RAW is an umbrella term applied to many
different kinds of file format currently in
development by the major hardware and
software manufacturers. At this stage,
no universal format has been adopted and
both Nikon (.NEF) and Canon (.CR2) have
their own versions.

2.8
RAW is the most
versatile file format and
allows a broader range
of editing techniques.

WHAT'S THE DIFFERENCE BETWEEN RAW AND OTHER FORMATS?

All digital cameras are fitted with a sensor responsible for detecting light and creating a chessboard-like grid of pixels to make an image. With JPEG, TIFF and other common formats, on-board camera software automatically applies hidden processing at the point of exposure to improve sharpness, contrast, colour and even compress data. Once captured and stored, these edits become 'baked' into your file and can never be removed, restricting future editing and creative interpretation of files. With RAW file formats, no such invisible processing takes place, resulting in an unadulterated file that is able to cope with more hand processing.

In addition to 'virgin data', RAW files also capture images with an extended 12-bit colour palette, effectively making a gigantic 4096 colour scale per colour channel, which increases the data size considerably. In general terms, a RAW file creates ten times as much data as an equivalent resolution JPEG.

RAW FILE BENEFITS

You can never save edits back into your original RAW file, regardless of the editing package you choose. This enables you to have a permanently uncorrupted version of your image to interpret for future use. Although not embedded, camera menu settings are carried alongside a RAW file and are used as starting points in your RAW file editor. You can make a desktop print from any open, edited RAW file easily enough, but if you want to send your edited work to a third-party service or client, then you need to export or save your file in an alternative format, such as TIFF or JPEG.

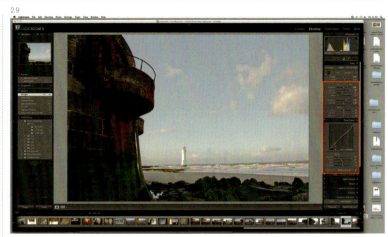

2.9

2.10a

2.10b

2.9
Unlike Photoshop, Lightroom allows you to edit RAW files directly.

2.10a–2.10b
Image 2.10a shows an original photo and 2.10b shows what happens after it has been over-compressed.

COMPRESSED FILES AND IMAGE QUALITY

The most data-efficient format to use is the compressed JPEG, usually available in three quality options: high, normal and low. Low quality provides the greatest data compression, but the poorest image quality. High quality shrinks the data to around 10 per cent of its original size with an image quality virtually indistinguishable from an uncompressed TIFF. Compression involves a clever mathematical sequence that minimizes the need for a discrete instruction for each individual pixel. As a result, compressed images take up far less space on a removable memory card and increase the number of shots available before the card gets full. The drawback with highly compressed images is a very visible blocky pattern, which cannot be removed with software processing.

APERTURE

There will never be a digital tool that can restore exposure or focus that wasn't correct in the first place, so if you want to take complete control over your image, understanding aperture is fundamental.

2.11

APERTURE AND EXPOSURE

The aperture is a variable-sized circular opening inside your camera lens used to moderate light levels for a successful exposure; it also determines depth of field. A typical lens has an aperture scale such as: f2.8, f4, f5.6, f8, f11, f16 and f22. When controlling exposure, an aperture of f2.8 creates the widest opening and lets in the most amount of light. At the f22 end of the scale, the aperture is at its narrowest and lets in the least amount of light. Each time you increase the size of your aperture by one step, the amount of light entering the camera doubles. Each time you decrease the size of your aperture by one step, it halves. Many digital cameras allow you to set intermediate aperture values, such as f9 (f8 and a third) or f10 (f8 and two thirds). Aperture values provide a consistent quantity of light across all different lens brands and models, so if you change a lens during a shoot, an identical aperture will be required.

APERTURE AND THE DSLR VIEWFINDER

By default, DSLR lenses remain fully open at their widest aperture value to make focusing and framing easier through the viewfinder. You'll see a marked increase in viewfinder brightness if you swap a dim f4.5 mid-range zoom for a brighter f1.8 prime lens. You can see more clearly and it's much less tiring on your eyes. As the shutter is pressed, the aperture diaphragm shrinks instantly to correspond with the aperture value you have selected; it then releases back to fully open when the exposure is complete.

2.12

2.13
At the f22 setting, much more sharp detail is rendered both in front of and beyond your primary subject.

2.13

2.14
Obtaining sharp detail is a combination of careful focusing, depth of field and using a mid-range aperture, such as f8.

2.14

SETTING APERTURE VALUES

Aperture values are usually accessed via a thumbwheel or menu on the rear of the camera body, but can only be selected when Manual or Aperture priority exposure modes are selected. In Auto and other program modes, the camera meter decides on an appropriate aperture value to generate a correct exposure, without taking your depth of field wishes into account. On digital compacts, there's usually a much-reduced set of apertures to choose from, such as f4 and f11. For creative photographers, Aperture Priority exposure mode is most popular as it lets them take control of depth of field and leaves the less crucial task of selecting an appropriate shutter speed to the camera.

APERTURE AND FINE DETAIL

In addition to affecting depth of field, aperture values also have a bearing on the amount of fine detail recorded in your image. All lenses perform best when aperture is set to the middle value of the scale. On a lens with a range from f2.8 to f22, the sharpest results will be produced at f8. Many websites share lens sharpness tests to help you make a better purchasing decision.

2.15

52

Cristina Garcia
Rodero's evocative study
of Cuba captures the
spirit of celebration.

SHUTTER SPEEDS AND MOVEMENT

The shutter is an integral part of the exposure mechanism, but it can also be used for stunning visual effects. Knowing when to press it could be the difference between getting the shot or not.

THE SHUTTER RELEASE BUTTON

The shutter is activated by the shutter release, which is the button you press down to take a picture. Only DSLR cameras turn the viewfinder momentarily dark during an exposure, as compact cameras use a separate viewing window to the taking lens and no such blackout occurs.

SHUTTER FUNCTION

The shutter controls the amount of time that the sensor is exposed to light. Like apertures, shutter speeds are organized into a standard scale, but measured in fractions of a second. Unusually, for an international measurement, shutter speeds are expressed in old-fashioned fractions rather than decimal values and are typically arranged as follows 1/1000th, 1/500th, 1/250th, 1/125th, 1/60th, 1/30th,1/15th,1/8th, 1/4, 1/2 and 1s. At the 1/1000th end of the scale, the shutter remains open only for a short time, but at 1/2 second, the shutter remains open for longer. Like the aperture scale, one step along the scale will either double or halve the time that the sensor is exposed to light.

2.15

2.16
A half-second shutter speed was used to blur the movement in this image.

2.17
Francisco Aires Mateus' simple study of a new building for elderly people uses a slow shutter speed to blur the single figure, which perfectly captures the sense of movement.

2.16

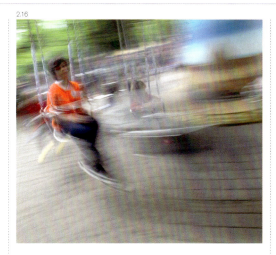

SLOW SHUTTER SPEEDS

If you want to create intentionally blurred effects, then a slow shutter speed will do the trick. Movement within photographic images can be a very expressive and atmospheric tool for creating a sensation of activity and action, but you do need to anchor your camera on a tripod first. Experiment with shutter speed settings from 1/2 to 1/8th of a second and if this doesn't create enough blur, then move the camera itself during exposure. Moving subjects, such as people, should be photographed side-on, so any movement trail is captured within the frame.

2.17

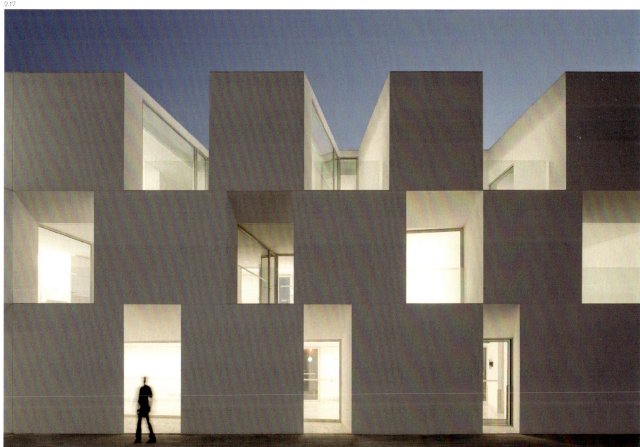

54

2.18
Bertie Gregory's
humorous study of a
raccoon was captured with
plenty of luck, but taken at
exactly the right moment.

TIMED SHUTTER SPEEDS

Good-quality digital cameras allow you to keep the shutter held open on the B setting for indefinite periods of time. Ultra-long exposure tricks are often used by architectural photographers to blur out moving people, leaving the static and important architecture to dominate the composition. This kind of exposure trick is made using special light-reducing filters called 'neutral density filters'. Without causing colour imbalance, ND filters reduce the light levels drastically, enabling the photographer to pick a shutter speed of several seconds without running the risk of overexposing the image.

2.19
A slow shutter speed
of 8s smooths out
the flow of water.

2.19

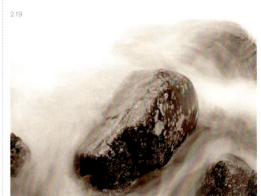

2.18

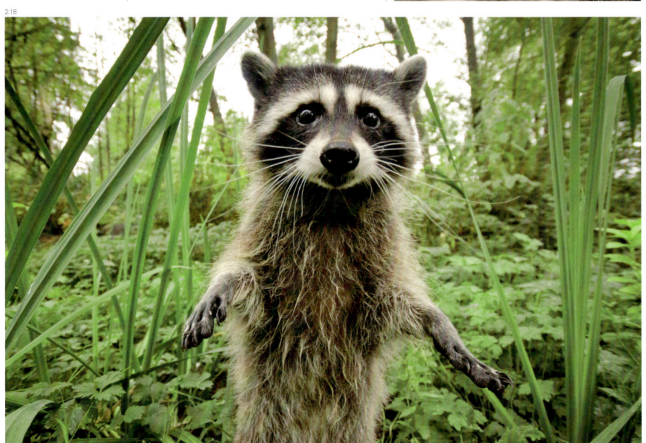

2.20

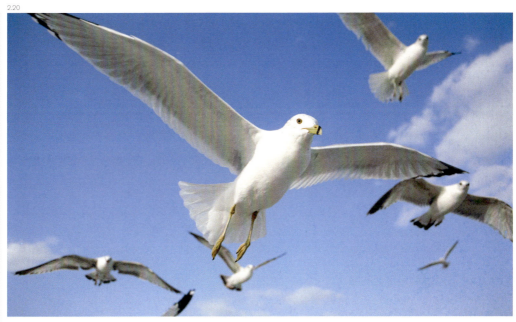

2.20
Fast shutter speeds such as 1/500 can freeze most movement.

FAST SHUTTER SPEEDS

For freezing sports and action subjects, the use of faster shutter speeds is essential. Faster speeds record motion and movement by capturing a fleeting slice of the action, far too brief for the human eye to ever focus on. Fast shutter technique forms the key to the very best wildlife and sports photography, but knowing where to position yourself to see the action is very important, too. As a general guide, 1/250th of a second is necessary for most walking and non-running human movement. For running and jumping action, the higher 1/500th of a second is necessary. For very fast action, 1/1000th of a second and over is needed (motor sports, horse racing, cricket and football). With fast shutter speeds, light hits the sensor only for a very short time, so light of a higher intensity must be used to compensate.

To increase light intensity, larger aperture values like f2.8 or f4 should be selected. If little natural light at the scene prevents the selection of a fast shutter speed, increasing the ISO value from 400 to 1600 will solve the problem.

CAMERA SHAKE

Unintentionally blurred images are generally caused by camera shake rather than poor focusing. Camera shake occurs when too slow a shutter speed is selected, coupled with a slight movement of the photographer's body, as the exposure is taken. Even the slightest of sways will cause the lens to move during exposure, resulting in a blurred result, regardless of how well you focused in the first place. The problem occurs most frequently when using zoom lenses on the telephoto end of the scale and especially in low-light conditions. As telephoto lenses capture far-off subjects, any slight body movement will cause the viewfinder image to change composition dramatically.

Camera shake can be solved by setting a shutter speed of 1/125th of a second or faster, but if faster shutter speeds can't be used, use a tripod or find a wall to steady yourself against. Long telephoto lenses used on DSLRs need a minimum 1/250th to offset the increase in camera shake due to the extra weight and awkward balancing involved.

2.21
Natural light can create a wonderful atmosphere, which would be difficult to recreate with flash.

EXPOSURE AND HOW TO MEASURE IT PROPERLY

Despite the convenience of rescue tools found in our image-editing software, there's no substitute for getting your exposure right first time in camera.

HOW LIGHT METERS WORK

Correct exposure is achieved through the right combination of aperture and shutter speed responding to location light levels, and makes a world of difference to your final image quality. Every DSLR has a built-in light sensitive meter that is used to determine exposure. A perfect exposure results when the photographer guides the meter into capturing a compromise between highlight and shadow detail. Too much or too little light will have a profound effect on image detail, tone and colour reproduction. Bad exposures occur when the photographer wrongly presumes that the meter knows the most important element of the picture.

APERTURE, SHUTTER SPEEDS, AND ISO AND THEIR RECIPROCAL ARRANGEMENT

With aperture and shutter speed scales, a single sideways step will either double or halve the amount of light hitting the sensor. With the ISO scale, the same steps will halve or double the sensitivity of the sensor. In practice and when using auto exposure functions, you will not be aware of this taking pace, but using a camera in manual mode, you will be acutely aware of their interrelationship.

A successful exposure made in manual mode relies entirely on the light meter, but it's important to understand that more than one combination of aperture and shutter speed will still let the same amount of light onto the sensor. For example, if your light meter advises you to set 1/60th of a second at f8, you can still achieve a perfect exposure by doubling the duration to 1/30th and halving the light intensity to f11 (although by using f11 you will create more depth of field).

WHERE TO TAKE YOUR READINGS FROM

The most important fact to remember about photography is that the camera light meter never knows the most important part of the image. The light meter can only respond to variations in brightness, so in many circumstances, you have to consciously trick the light meter into behaving differently. With so many different levels of light reflecting off objects in your composition, the best exposure is a trade-off between recording simultaneous detail in both highlights and shadow areas.

Most good digital compacts have an exposure lock button located close to your shooting hand, or accessible when the shutter is half-depressed. Exposure lock is a very useful device so you can take light meter readings from the important areas of your image, save the reading then recompose before shooting.

2.21

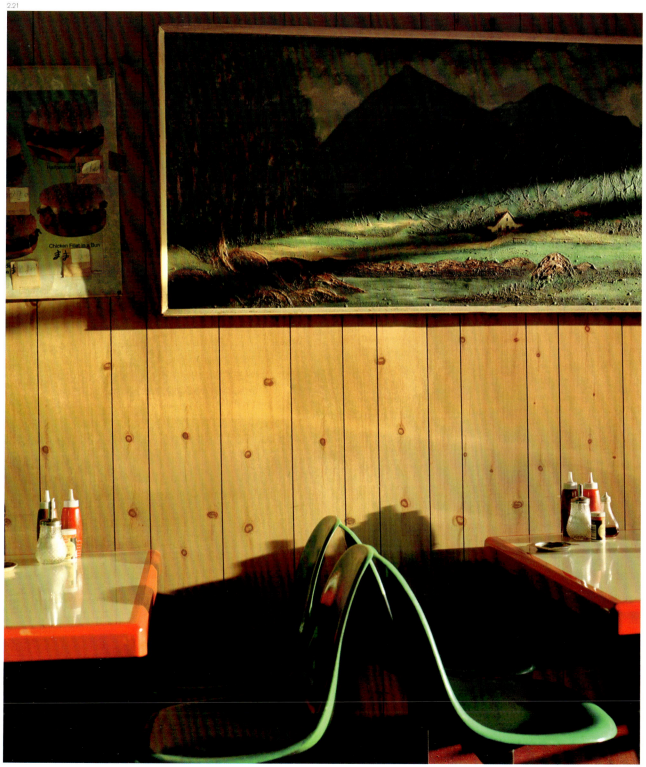

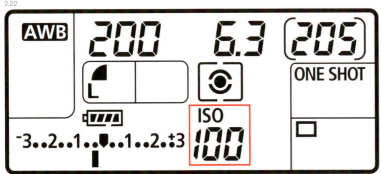

2.22

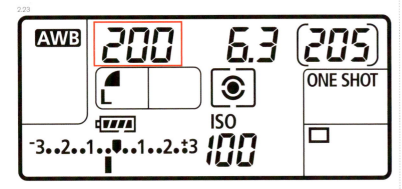

2.23

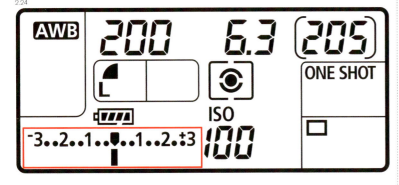

2.24

MAKING A MANUAL EXPOSURE MEASUREMENT

Step 1: Set your ISO

The ISO scale sets the sensitivity of the image sensor and at low light levels a higher ISO value like 800 is best selected, so the sensor can operate with less light than normal. At bright light levels, a smaller value like 100 is set (see image 2.22). Once your sensitivity has been set, then the right combination of aperture and shutter speed needs to be found to make a good exposure. Compose your subject.

Step 2: Set your shutter speed

Unless you're shooting a moving subject, set the shutter speed scale to 1/125th of a second to prevent camera shake from ruining your image (see image 2.23). Slower speeds can be used, but only with a tripod.

Step 3: Check your exposure read-out scale

Next, look at the exposure read-out scale in your viewfinder or on the top LCD panel (see image 2.24). This scale will have a centre line and a scale showing minus values to the left and plus values to the right. This scale tells you that your image will be dark and underexposed (minus values) or bright and overexposed (plus values). Underneath the scale is a moveable dot or light indicating the current setting.

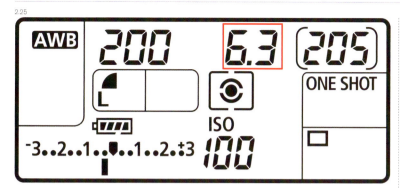

2.25

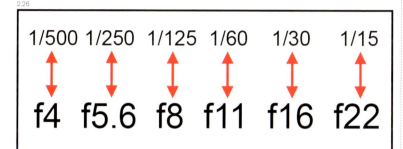

2.26

Step 4: Set your aperture

Your task is to change the aperture value until the moveable dot or light sits exactly underneath the central point. This will achieve perfect exposure. In this example it's f6.3 at 1/200th of a second (see image 2.25).

Step 5: Decide on your combination

When you have measured the available light, you've effectively 'locked' the halving and doubling aperture and shutter speed scales together. Now, each linked combination of aperture and shutter speed will create a perfect exposure, but with more or less depth of field (aperture) or subject movement (shutter speed). Which one you choose depends on what you're trying to communicate through your image (see image 2.26).

2.27a–2.27c
Examples of
centre weighted,
matrix or evaluative,
and spot metering.

CAMERA METERING MODES

There are three common metering systems used in digital cameras; centre weighted, matrix or evaluative and spot metering.

2.27a

Evaluative or matrix metering is the best one to use and works by taking individual brightness readings from lots of different parts of the scene. These readings are averaged out into a single exposure reading, resulting in a better compromise between light and dark. The more complex spot metering system takes a reading from a much smaller area, typically the tiny centre circle superimposed in your viewfinder. Useful for getting accurate light readings from skin tones or other smaller and precise elements of a composition, a successful spot reading will emphasize this over other less important parts of your image.

2.27b

2.27c

JUDGING EXPOSURE ON THE REAR LCD SCREEN

All DSLRs and top quality compacts offer the useful benefit of a Levels histogram when an image is played back on the rear LCD preview monitor, so you can see exactly how an image has been recorded. The histogram offers the best way to judge your exposure.

2.28

2.29

2.28
Overexposed images are bright and have little detail and very washed out colours. Overexposed images display a strong pixel count in the right-hand half of the histogram.

2.29
Underexposed images are dark, lack detail and have muddy colours. On the histogram, the pixel count is high towards the left-hand side describing the large quantity of black or dark grey pixels present.

2.30

Most good digital compacts and all DSLRs have an additional exposure control called the 'exposure compensation control', identified by the +/- symbol. This can be used to counteract lighting situations that would otherwise fool your light meter. It works by allowing more or less light to reach your sensor as follows: to increase exposure, use the + settings, and to decrease exposure, select the − settings. Each whole number represents a difference of one aperture value, commonly referred to as a 'stop'.

THE EXPOSURE COMPENSATION CONTROL

2.30

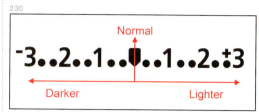

BRACKETING

If you don't want to spend time worrying about achieving the right exposure with each and every shot, a sensible way to approach tricky exposure situations is to bracket. A number of different exposure variations are taken of the same subject. Bracketing is essentially an insurance against failure and even the most demanding situations can be covered within a five-shot range. It only works on stationary subject matter and is best done with your camera fixed to a tripod, so five identical results are produced. If your camera doesn't offer an auto-bracketing function, you can easily do it manually using the exposure compensation dial. This example (images 2.31a–2.31e) shows a five-shot sequence all with slightly different exposures.

2.31a–2.31e

Bracketing is essential when faced with contrasty subject matter.

2.31a

2.31b

2.31c

2.31d

2.31e

CAMERA PROGRAM MODES

Both DSLRs and digital compact cameras are designed with extra shooting modes to cope with different creative situations that cannot be captured quickly with manual controls.

EXPOSURE-RELATED MODES

DSLR cameras allow you to shoot in full manual mode where you select both aperture and shutter speed values and have two core program modes for faster operation: aperture priority and shutter speed priority.

PROGRAM MODE

Program mode offers the least control over how the final image looks. Here, the camera chooses both shutter speed and aperture value based on the light available and translates this into a shutter speed that prevents camera shake, typically around 1/125 of a second and a mid-range aperture setting such as f8. The downside to using Auto mode is that your results will be entirely dependent on the amount of available light rather than any creative decision that you make.

SUBJECT-RELATED MODES

DSLRs also cluster together groups of settings for shooting certain subjects, such as portraits, close-up, landscape, sports and action. Although timesaving and easy to use, you'll get results that are more predictable by shooting in manual mode and understanding how groups of settings influence the result.

PORTRAIT MODE

The portrait mode is nothing more than a simple setting designed to shoot at the widest aperture that available light permits. To allow shooting at a wide aperture, the camera will need to set a fast shutter speed to counteract the extra light intensity created by f4 or f5.6. When shooting at a wide aperture, any background details will be blurred out, providing your subject is not standing too far away and you are using the telephoto rather than the wide-angle setting on your zoom lens. This effect will create a shallow depth of field and provides more emphasis on your portrait rather than the background.

2.32

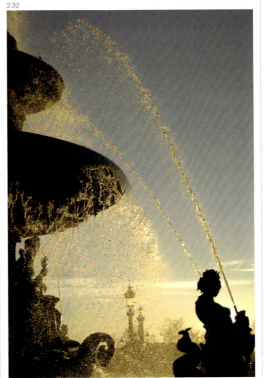

2.32
Shutter speed priority mode is the reverse of aperture priority, letting you set a deliberately fast or slow speed to freeze or blur your subjects, while the camera sorts out the aperture setting. A setting of 1/250th of a second was used to freeze this waterfall.

2.33

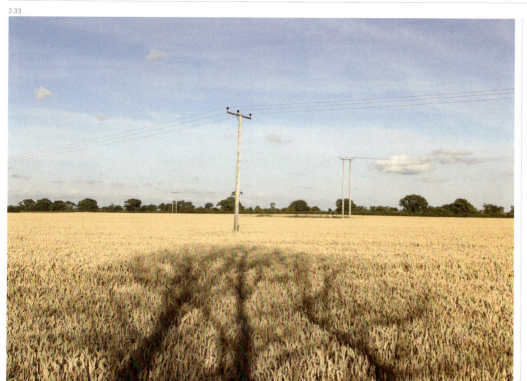

2.33
Aperture priority mode
is the most popular auto
exposure option found
in DSLRs and better
compact cameras. Aperture
priority works when the
photographer defines
the aperture value and
the camera sets the right
shutter speed to make a
correct exposure. Aperture
priority is useful when you
want to create a particular
depth-of-field effect. This
example was shot with an
aperture value of f16.

2.34

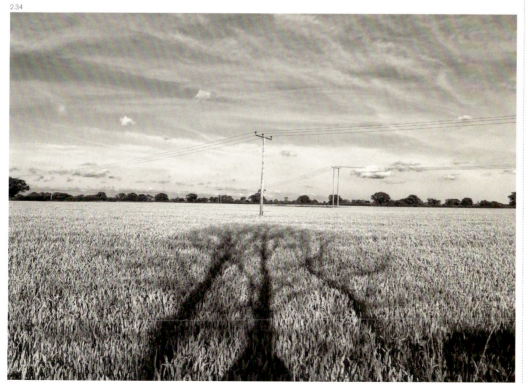

2.34
DSLRs also combine
different camera software
edits into special modes for
enhancing the look of your
images. Black and white,
sepia and high colour are all
such examples that can be
applied to JPEGs in camera,
but not RAW files. It's more
flexible to apply these kinds
of effects using computer
editing software rather than
in-camera. This example
was captured with a custom
black-and-white preset.

2.35

64

Olivia Arthur's clever observation of evening drinks at the Little Rock Café in Amuria, Uganda, uses the lens to shoot through a narrow gap in an open doorway. (Courtesy of Olivia Arthur/Magnum Photos for Water Aid.)

THE LENS AND FOCUSING

Understanding exactly how a camera lens works is the key to taking better photographs. Not only does the lens assist in composition – it can also be used to shift unwanted areas of your scene out of focus.

2.36

2.35

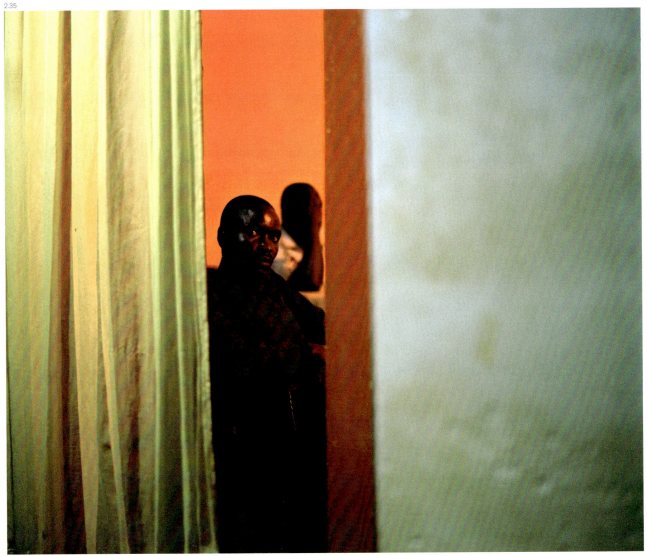

2.36
Better DSLRs have sophisticated autofocus sensors which are able to detect subjects lying outside the central frame.

2.37

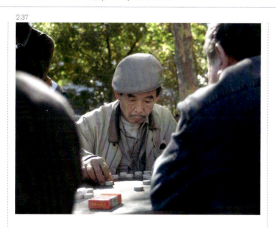

AUTOFOCUS

DSLRs use autofocus to remove the human error out of picture taking. Most cameras have multiple autofocus targets superimposed on the viewfinder, which track your subject. Autofocus is activated by half-depressing the shutter button until a confirmation light appears in the viewfinder display. Most cameras will not fire if the lens is unable to focus on very close subjects. Every lens has a minimum focusing distance and will not be able to make sharp results from subjects that are too close.

All DSLRs have the option of manual focusing for more creative effects, usually switched on and off on the lens barrel. Better DSLRs are fitted with different autofocus options: the single servo mode and the continuous tracking mode. Single servo is mostly used for shooting static subjects; continuous tracking is used when subjects are moving across the frame or towards you.

AUTOFOCUS LOCK

Autofocus is unable to focus on low-contrast subjects, like large areas of flat colour, and will track the lens back and forth in error. This problem is easily solved by recomposing and focusing on the edge of the subject first, then holding the autofocus lock on your camera body. The lock holds the focus setting in place, so you can recompose and shoot more creative results. Most cameras have the lock in an easily accessible place, so you can carry out focusing without taking the camera away from your eye.

WHAT TO FOCUS ON

Choosing the right point of focus before the shot is taken can really enhance your depth of field. In normal shooting, the temptation is to focus on the main subject regardless of how near or far it is from the camera lens. Depth of field ranges from one third in front of your subject to two thirds behind it, so a third of sharp focus is often wasted in the foreground if you focus directly on your subject.

The best kinds of results are achieved when a focus point is carefully selected at one third of the distance from the intended foreground to background. In principle, this sounds impossibly complex, but better SLR cameras have a depth of field preview button, which gives a preview of the likely result before shooting commences.

2.37
Blurring objects in the foreground can be a really effective way of making the viewer feel like they are present in the scene itself.

2.38
Shallow depth of field combined with focusing on close subjects, creates a sharpness fall off before and after the focus point.

2.39
Using a conventional mid-range zoom lens, no depth-of-field setting would allow you to separate the foreground, middle ground and background if they are distant from the photographer.

DEPTH OF FIELD

Determined entirely by the lens aperture setting coupled with your own proximity to the subject itself, depth of field is unique to photography.

When looking at the world around us, the human eye focuses so quickly on subjects at different distances that we hardly notice the transition. In fact, we are blissfully unaware that we can't keep sharp focus on both a close-up object and the distant background simultaneously. With photography however, you can get the best of both near and far worlds and create an image that presents more information to the human eye than reality.

WHAT IS DEPTH OF FIELD?
Depth of field is a photographic term used to describe the plane of sharp focus that is set between the nearest and furthest parts of aphotographic scene and can be varied from a matter of millimetres to infinity. Professional photographers use both shallow and deep depth of field to emphasise their subject matter to make much more memorable images.

IF THE SUBJECT IS FAR AWAY
If a potential landscape image is divided into foreground, middle ground and background, then it's important to realize that you can't separate objects lying in the same plane with shallow depth-of-field effects. As subjects get further into the background, it becomes increasingly impossible to assign sharpness to one element and not the other. For mid-range zoom lenses found on most digital compacts, anything more than five metres away will record with a similar level of sharpness as the furthest parts of the scene.

2.38

2.39

2.40a–2.40b
Close-up photography: the same photograph was taken twice using different aperture values to see how much detail could be recorded in the background. Image 2.40a was shot at f4 and shows a noticeable background blur. Image 2.40b was shot at f16 and shows a much more distracting background.

2.40a

2.40b

FOCUS POINTS

Especially important when focusing at close range is a third factor: your exact point of focus. As depth of field extends to both in front of and behind your point of focus, it's essential to pick the right spot to gain the best results. A much better rule is to pick the nearest and furthest parts you want sharp, then focus one third of the way in. For stationary subjects, like still life, this can easily be estimated while your camera is placed on a tripod.

USING PHOTO INFORMATION

A much underused feature of digital photography playback is the photo information captured with your image file. This panel of settings is recorded and stored with most digital images and can be reviewed in your image browser and editor after transfer to your computer. The photo information records the vital aperture and lens focal length settings so you can tell exactly how a depth-of-field effect was created.

DEPTH OF FIELD AND LENS MAXIMUM APERTURE

Cheaper zoom lenses are convenient, but often have a poor maximum aperture, such as f4.5/5.6. For special shallow depth-of-field background effects, a maximum aperture of f4.5 won't blur things as much as an f1.8 lens will. Although more expensive, lenses with wider apertures give you much more creative control.

2.41

When shooting close-up, depth of field shrinks to a matter of centimetres.

2.42

Sports photographers shoot on f2.8 or f4 to blur out backgrounds, with no margin of error.

2.43

2.42

2.41

SHOOTING AT RANGE

If you want to single out delicate individual subjects from messy and cluttered backgrounds, then use your widest aperture together with your zoom lens at its maximum telephoto setting. Hold your camera carefully to prevent camera shake, as any slight blur will be magnified when using this approach. Pick your focus point carefully and make sure your autofocus doesn't settle on a distant subject by mistake. This kind of shooting forms the standard technique for all professional sports photographers, where great images can be spoiled by backgrounds that are too detailed and distracting.

DEPTH OF FIELD CLOSE-UP

Unfortunately, depth of field doesn't remain constant throughout the far-reaching landscape and close-up photography. As you get closer and closer to your subject, the effective depth of field diminishes rapidly until it can be reduced to a matter of millimetres, even at maximum f16. If you want to capture finely detailed images at close range your small apertures will force you to use much slower shutter speeds than normal and necessitate the use of a tripod.

2.44

2.43
Shooting deep depth of field: this image shows a sweep of sharpness from foreground to background achieved with an aperture of f16 and a set focus point at a third of a way in.

2.44
Shooting shallow depth of field: this effect is used to blur out a distracting background and allows a greater emphasis to be placed on the main subject. This is created by selecting a large aperture like f2.4 or f4 and framing your subject tightly in the viewfinder.

VIEWPOINT

The outline or shape of a subject varies depending on your viewpoint and can be manipulated into a stylish and graphic photograph.

YOUR OWN VANTAGE POINT

Amateur photographers often shoot from the same viewpoint, usually from a standing position. For these users it's very rare to consider changing their shooting position unless there's a clear need to cram more people into the viewfinder. Two alternatives to the normal standing position are the worm's eye view and the bird's eye view.

2.45

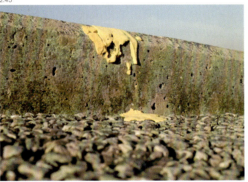

2.45

Squatting with your camera pointing upwards will make subjects look domineering, monumental and bigger than they really are.

Shooting downwards from a raised position, such as a bridge or upper floor window, will make things look tiny and insignificant. As a photographer, you can design your image with links from foreground to background by cleverly organizing lines and intersecting shapes in your viewfinder.

As we view a photographic image, our eyes are influenced and guided by strong lines and diagonals, much like a game of snakes and ladders. These kinds of skilfully structured photographs hold a viewer's attention and are much better than amateur accidental snapshots.

OPPOSITES ATTRACT

Stylish images often result from a meeting of two opposites, such as old and new, dark and light, or straight and curved. Opposites offer the viewer more of an interesting visual experience by providing different areas of the image to compare. In our normal everyday life, we never visually dwell on discrete rectangular 'scenes', but the value of photography lies in its ability to draw our attention to the unnoticed world around us. Image 2.46 was created by using a long 100mm lens, which helped to foreshorten the distance between the tree and the background.

2.46
Using a standard lens allows you to create dynamic crops and exclude large areas of your shooting scene.

2.47
Pattern and repeats can make interesting subject matter.

2.47

2.48
Tilt the frame to create more dynamism in an otherwise static subject.

FRAMING WITH LIVEVIEW

On the rear of a DSLR camera is the LCD preview screen, where photographers can, for the very first time, contemplate a two-dimensional scene before pressing the shutter and visualize exactly how the final print will be balanced. With all the advantages of real-time framing, holding the camera steady at arm's length can be an easier way of pre-visualizing the end result and is a great way of shooting from unexpected viewpoints, such as floor level.

2.46

2.48

TILTING THE FRAME

When faced with a simple subject, it can be initially difficult to know which angle to shoot from, but it's well worth the effort to shoot a few variations. Different lenses will enable you to distort shape in varying degrees, with wide angles creating the most stretched-out effects. Try tilting the verticals so they flow diagonally across the frame.

COMPOSING YOUR IMAGE

Composition is the skill of organizing a subject or scene into a balanced arrangement in the camera viewfinder.

2.49

2.49
Overcrowding your viewfinder creates a 'squashed-in' effect, which can be visually interesting.

FRAMING IN THE VIEWFINDER

Great photographs are made at the moment the shutter release is pressed, but most critical judgements are made beforehand in the viewfinder or the rear LCD preview screen. In addition to the image, most cameras also provide overlaid information in the display, such as focus and exposure confirmation. Large viewfinders are easier to use, especially if you wear glasses and find it hard to see through a tiny window.

No photographer was born with innate compositional design skills, most of us borrowed ideas along the way. For immovable subjects or those essentially out of reach like a spectacular natural landscape, composition is completely influenced by your own shooting position, together with your choice of wide angle or telephoto lens. For more pliable and nearby subjects like people, composition can also be determined by your own direction and people organization skills. Without a sense of adventure or the willingness to experiment, most amateur photographers place their subjects centrally in the frame and don't take advantage of dynamic compositional effects.

2.50a

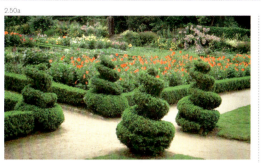

2.50b

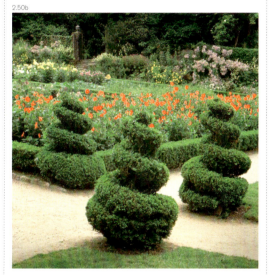

2.50a–2.50b
Cropped to a square, this image now works better.

BALANCE AND WEIGHT

Experience comes with shooting many photographic situations over time and an intuitive understanding of visual balance will follow. When organizing scenes in your viewfinder, each different element in your composition will vie for visual attention by its shape, colour, size and position. Over-cluttered compositions with too many elements in too many areas of the image lack emphasis and fail to send out a clear message. Strong colours and heavy textures can also dominate and swamp your main subject, as can intensely patterned backgrounds. If you can't move these objects out of your frame, a good way of minimizing their destructive effect is to blur them out using a wide aperture value.

Visual weight can be described as the effect of a colour or tone pulling the viewer's eye in a particular direction and if used effectively, can act as a counterbalance to the central subject. The best way of getting into this kind of thinking and picture taking is to look at books of great photographs and see how others have used these rules to good effect.

SYMMETRY AND ASYMMETRY

The easiest kind of balanced composition to make is a symmetrical one. Symmetrical photographs are those which have near identical elements on either side of an imaginary vertical or horizontal fold and are, as a consequence, very eye-catching. As a starting point, place the main elements of your composition in the centre of the frame until a balance is achieved along the vertical or horizontal axis. Architectural and landscape subjects work well with this kind of approach, but you may need to pull in additional items in the frame to balance things out. These kinds of image don't need to be mathematically equal and can look very artificial if done so.

EMPHASIS

So many photographic images are viewed and dismissed within a fraction of a second, so anything that makes the viewer dwell for longer is a good thing.

2.51

VISUAL ORDER

Compositional skills are only gained through the experience of shooting different photographic situations under different circumstances. Like fitting together a jigsaw, photographic composition is based on the position of shapes. Saturated colours and detailed patterns can overwhelm the main subject, as can sharply textured backgrounds. Distracting elements can easily be removed from your work by simply changing viewpoint, lens or if you can't move these objects out of your frame, blur them out using a wide aperture like f2.8. Visual weight is the effect of a strong colour or tone pulling the viewer's eye in a particular direction and if used effectively, can act as a counterbalance to the central subject.

2.51

The spiral shape helps to convey three-dimensional space.

2.52

Lines can help direct the eye within the picture frame.

2.52

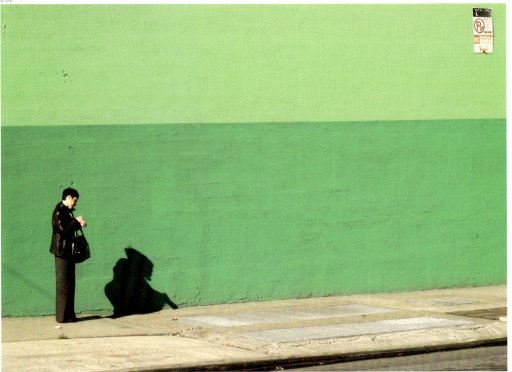

BALANCE

When faced with a subject in your viewfinder, each different piece of the visual jigsaw will vie for your attention. Busy and cluttered compositions result from too much emphasis in too many areas of the image, and lack a strong emphasis and a clear message.

THE RULE OF THIRDS

An excellent set of guidelines to base your landscape photography on is the ancient, but still applicable rule of thirds. This theory suggest that an image should be divided into a grid of nine equal, but entirely invisible sections and was adopted by many artists and painters in western art movements. The idea of the rule-of-thirds theory suggests that as long as elements are placed on these grid lines, or at their intersections, a pleasing compositional result can be achieved. Next time you are out shooting in the open landscape, try some variations on this theme.

VISTA VIEWS

Great use can be made of diminishing distance and depth within the photographic frame. The limitations of natural light and your own five- to six-foot-high viewpoint rarely allow you to cram more than a few miles of distance into a single shot at the best of times. Open space and the sweeping extent of the countryside can be captured to good effect with a vista view.

Vistas are made when a set of parallel lines merge into each other at the vanishing point on the horizon and in addition to making a great graphic effect, lead your eye from the foreground of the photograph to the background.

2.53
This image shows how the rule of thirds can be applied to a landscape subject.

2.53

2.54

BIG IS BEST

Most amateur photographs, especially those shot on unsophisticated and older film-based compact cameras never get close enough to the subject. If you are worried about chopping off the heads and feet of your portraits, then you are probably standing too far away. A tall and thin person doesn't easily fit into the shape of your viewfinder, so zoom in closer or move your own position to crop out unnecessary details. Getting physically closer to your subject has an additional advantage, too, as detailed backgrounds will become more blurred and less distracting to the eye.

2.54
This image shows a vista view.

76

SEEING THE WORLD IN MONOCHROME

Shooting with black-and-white film has long been established as the all-time favourite with independent photographers, yet in the digital era, monochrome photography has even more potential.

2.55a–2.55b

A monochrome version of a colour image can help to draw out texture if lighting wasn't perfect at the time of capture.

2.55a

2.55b

PERCEIVING MONOCHROME

Where colour photography is a chocolate box of different visual treats, black and white is primarily about the essentials of light, line and texture. It's perfectly possible to pre-visualize a black-and-white photograph while shooting on location, but you'll get great quality results if you concentrate on some or all of the following essential elements.

Apart from the post-production skills of stylish black-and-white photography, you've got to be able to spot potential monochrome images when strong colours are largely absent. When natural light is dull and your subject colours don't sing, mono can add texture and contrast to the most mundane situations.

Although many DSLRs offer a Black and White picture style mode, a much better option is to shoot RGB and convert your files in your image-editing application. With a comprehensive assortment of tools for converting colour to black and white, there's simply no advantage in starting with a monochrome original. The great beauty of the black-and-white process is the ability to make original colours darker or lighter by transforming them into different areas of grey without looking overcooked and invented.

2.56

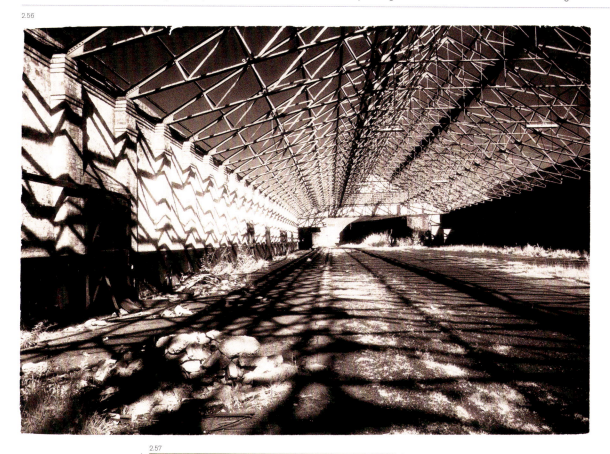

2.57

2.56
A high-contrast image.

2.57
A low-contrast image.

HIGH CONTRAST AND LOW CONTRAST

When strong whites and blacks are present with very few accompanying grey tones, the result is said to be high contrast. Best suited to strong shaped subjects, high contrast effects will enhance lines, edges and textures and is the way to get a bit of realism into your work. The end result of a high contrast print is usually a strong graphic image which attracts attention due its stark difference from the way we normally see the world. As a by-product of the process, finer details found in mid-tone grey areas will disappear, so this kind of style is best used when delicacy is not desirable. This style is a good way to shoot a photo story out on location, particularly if it's based around a strong issue or theme.

ASSIGNMENT: 20 DIFFERENT VIEWS OF THE SAME THING

2.58a–2.58b
Emer Gillespie often places her pictures in pairs to create a visual connection and comparison between two images.

2.58a

2.58b

Choosing subject matter that you can shoot in many different ways helps you to develop your creative focus.

THE BRIEF

Pick a person, object or place and create 20 different images of the same thing, using a wide variety of shooting techniques. Experiment as much as you can and see if you can make each image as different as possible. Use natural daylight to keep your shooting simple and explore all the different techniques that you have learned in this chapter. To get you started, consider the following:

1 Shooting position – close-up or far away; facing the light or casting a shadow; cropping in the viewfinder or with your zoom lens; tilting your camera to make diagonals; bird's eye view or worm's eye view.

2 Lens control – shallow depth of field or deep depth of field; blurring; using wide and telephoto lenses.

3 Composition – filling the frame or leaving space around your subject; chopping off and selective framing; busy or minimal compositions.

4 Make a contact print of your final 20 images and annotate each with a description of the technique you have used.

2.59

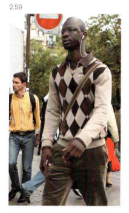
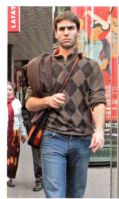
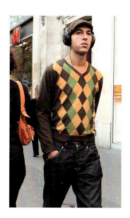
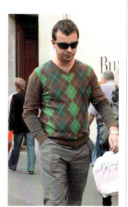

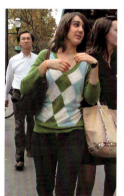
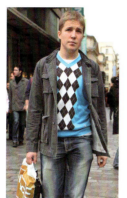

2.59
Hans Eijkelboom creates collections of similar finds on the street. Here, he's observed a fashion trend for diamond-patterned jumpers. Presented as a photo book or a print, the significance is increased by the quantity of different images.

CHAPTER 3

THEMES AND THEIR WORKFLOWS

The purpose of this chapter is to engage you in practical tasks and to encourage you to move beyond the pictorial shooting skills that come with competent camera operation. With so many images being produced every second of every day, your task is to create compelling photographs that demand attention and deserve further scrutiny from an increasingly image-savvy public.

Great photographs are not just observed, but planned, devised and conceptualized by photographers, who offer us the unexpected and challenge our expectations. Many of the photographers discussed in the following projects will not have used digital cameras to make their work, but the creative skills that they have employed are as relevant to digital photography as to analogue photography. There are millions of would-be photographers showing off their work on the Internet, your task is to become conversant with the innovators.

'For me, the importance of photography is that you can point to something, that you can let other people see things. Ultimately, it is a matter of the specialness of the ordinary.'
Rineke Dijkstra

PROJECT: TRACES AND PLACES

'Throughout Walker Evans' long career, commentators often remarked on the transparency of his pictures. They were thought to represent the thing itself, seemingly without intervention. Yet they are documentary interventions of the highest order.'
David Levi-Strauss

THE BRIEF

The purpose of this project is to establish your observational skills and your understanding of the documentary genre. Devise and develop your own personal response to one of the following themes:

1 Signs of the times

Consider how buildings, shopfronts, public spaces, and street furniture can represent the precarious nature of our economy (see image 3.1). Research Walker Evans' images of crumbling roadside America, which have become potent symbols of the depression era.

2 Marking out

We define our territory in the environment in many different ways through graffiti, signage and even the fences we place around our property. Look at the work of André Kertész, especially how he uses composition to exclude things from the frame. Sometimes it's the surrounding stuff that you leave out which makes an image stronger (see image 3.4).

3 A special collection

By finding and grouping together similar subjects, you can create links between previously unconnected things. Look at the work of Bernd and Hilla Becher, especially their cool and detached studies of water towers.

4 Beneath the surface

Close-up textures of weathered material (see image 3.3) can symbolize decay, but also provide abstract images of an unnoticed world. Explore Aaron Siskind's super-sensory photographs, which show exquisite visual scenarios in the most unlikely of places.

5 Out of season

Faded, empty and downtrodden tourist spots are atmospheric locations for a documentary shoot (see image 3.2) and best when the light is grey and brooding. Look at Eugène Atget's carefully composed photographs of deserted Paris, where he turns the most ordinary shop display into a surrealist statement.

Output

Produce a minimum of four final prints of your chosen subject.

3.1

3.4

3.2

3.3

RESEARCH THE US LIBRARY OF CONGRESS

The Prints and Photographs section of the US Library of Congress provides a comprehensive resource for the study of historic photography. There are hundreds of Walker Evans and Dorothea Lange images to view and print out for your research folder. www.loc.gov/pictures.

PROJECT: NATURAL OR MAN-MADE

'I work from awkwardness. By that I mean I don't like to arrange things. If I stand in front of something, instead of arranging it, I arrange myself.'
Diane Arbus

3.5

Patterns of nature can be found in any open space.

THE BRIEF

The still life is a subject that has passed down through generations of artists. For photographers, the theme of still life allows you to exercise your identification skills in a different way. Objects collected and stripped away from their original context can symbolize a deeper meaning – they can be used to construct a story rather than represent themselves.

This assignment will develop your skills of selection and arrangement. How you position yourself and the components of your still life will determine the overall message. Devise and develop your own personal response to one of the following themes:

1 Iconic simplicity

Sometimes, photographic images are made stronger by leaving things out. Seek out simple objects and reposition them in a sympathetic setting, creating an image with fewer rather than many elements. Look at the work of Josef Sudek, especially his evocative studies of glasses of water against his studio window.

3.5

2 Perfect specimen

Repeating patterns of nature can be found in the most unlikely subjects in your local park or garden. Find an intricate pattern and isolate it against a plain background, either on location or in the studio. Look at the carefully observed photography of Karl Blossfeldt and W. A. Bentley's famous close-up of ice crystals – see how they 'collect' specimens of the natural world.

3 Forensic observation

Rubbish can symbolize all that's bad about the consumer society within which we live. Find and retrieve four discarded items and shoot them close-up to reveal the traces of their past use. Irving Penn, the master of fashion and portrait photography, produced a radical series of close-up photographs of squashed cans and flattened cigarettes found on the street. Shot close-up and enlarged to an enormous size, Penn made rubbish look as visually interesting as an abstract expressionist painting, whose textures and gestural brushstrokes caught the spirit of post-war America.

4 Construction site

Constructing a still life out of organic materials, such as flowers, fish and sea life, has made Michiko Kon's images very recognizable. Kon made a dress out of chicken's feet and a ballgown from herring, both using small-sized, natural forms repeated or arranged in a pattern to create a more complex end result. Find and arrange natural items to create a special object for the camera, perhaps with symbolic undertones.

Output

Produce one final print of your chosen subject.

3.6

RESEARCH VANITAS PAINTING

Some of the most intriguing still-life images were painted in the vanitas tradition in the sixteenth and seventeenth centuries, to remind us of the shallowness of material things and life. Each object in a vanitas painting is deeply symbolic, leading to much speculation over the artist's intentions.

3.6
This is an image of a Michiko Kon still life.

PROJECT: THE STREET

'I go straight in very close to people and I do that because it's the only way you can get the picture.'
Martin Parr

THE BRIEF

Street photography is all about risk taking and spontaneity, where you respond quickly to the fleeting action in front of you. You'll be trying to fulfill Henri Cartier-Bresson's fundamental principle of photography – called the 'Decisive Moment', when the significance of an event is visualized and organized in a fraction of a second. As shapes and subjects collide into momentary harmony, your skill is choosing the right moment to press the shutter. A second too soon or too late, and the image has gone.

Operating in a public space means you will need to be wary of being seen, but also have the confidence to approach total strangers. Devise and develop your own personal response to one of the following themes:

1 Organizing chaos

Research the work of Lee Friedlander, who shoots the constantly shifting relationships of signs, symbols and traffic, creating a body of work that makes order out of visual chaos. Look for unrelated and unconnected subjects on the street and use your compositional skills to crop and arrange into a visually pleasing result.

2 The tourist

Martin Parr is noted for his clever observations of tourists, shot with a cruel sense of humour (see page 143). Find a crowd of moving people and use a wide angle to grab the atmosphere of fleeting movement. Try shooting from waist level or above head height – without looking through the lens. You'll need to shoot several hundred images and you'll have a high number of mistakes.

3 Lost in transit

Look at Tom Wood's seminal project *All Zones Off Peak,* which was made by the photographer riding on buses and observing his subjects without being noticed, like Walker Evans' photographs on the New York subway. For this project, conceal your camera and try to capture the dreamlike state of the traveller.

4 Passers-by

Discover Katy Grannan's *Boulevard* project, which uses the neutral white walls and strong noon light to capture the fading glamour of Los Angeles' residents. Choose a street location that will give you a neutral background for your study, and then capture a sequence of passers-by during the day.

Output

Produce a minimum of 200 images of your chosen subject, and then choose four finals.

3.7
Jo McGuire captures
a sensitive portrait of a
man and his best friend.

3.7

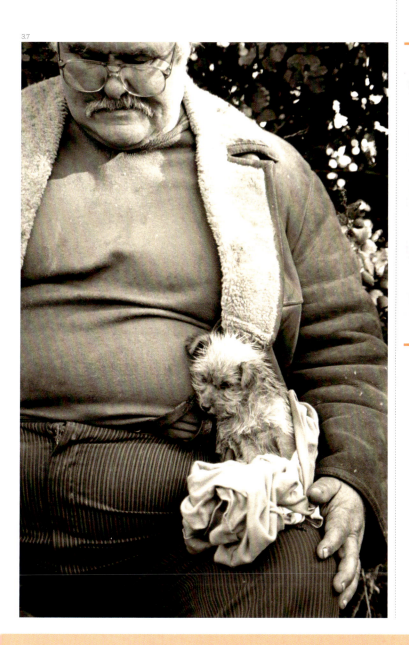

RESEARCH MAGNUM PHOTOS

Established by photographers Henri
Cartier-Bresson, Robert Capa, George
Rodger and David Seymour, Magnum
Photos has some of the greatest street
photographers on its books. Look at the
latest work of Martin Parr, Bruce Gilden
and Elliott Erwitt.
www.magnumphotos.com

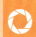
PROJECT: TRUE STORIES

'I discovered that this camera was the technical means in photography of communicating what the world looks like in a state of heightened awareness. And it's that awareness of really looking at the everyday world with clear and focused attention that I'm interested in.'
Stephen Shore

THE BRIEF

Storytelling photographs are made when the photographer develops an in-depth understanding of a cultural environment. In practice, this means researching and reading around your subject. A good photo story works best when the sum of the parts are greater than any single image. Aim to capture your subject with a broad brushstroke, shooting details and incidentals, as well as the main characters, to give a flavour to your story.

The scope of a photo story can sit comfortably within a double-page magazine spread or fill an entire book. Your task is to create a storytelling piece about one of these themes.

1 After the event

Research James Tye's project 'Still Standing', which cleverly photographs professional boxers just after they've left the ring at the end of a fight (see www.jamestye.com). The fighters show a mixture of emotions, some with their guard down, some still tense, but we don't know who's won or who was beaten. Pick a situation to shoot where you focus on the reaction of a person in the aftermath. The context will be hidden in the image from the viewer, but revealed by a short accompanying statement. Aim for an ambiguous end result, where you encourage the viewer to construct their own narrative.

2 Pastimes

Ricardo Cases' *Paloma Al Aire* is an affectionate study of pigeon fanciers in the Spanish regions of Valencia and Murcia. Cases creates visually arresting images using the colours, textures and movement within the pastime. Find out about a hobby that's practiced in your local community, especially if it's outside your age group. Join up and document the activity as a member and participant, producing a story with a celebratory feeling rather than a cynical undertone.

3 Unofficial guidebook

Federico Clavarino's book *Ukraina Passport* is designed to fit inside a cheap plastic passport cover and provides an alternative view of the Ukraine (see page 190). Mixing past and future, observation and fabrication, Clavarino's book reminds us of the gap between officialdom and reality.

Output

Produce eight final images arranged in a sequence, with an accompanying title and short 250-word statement.

3.8a

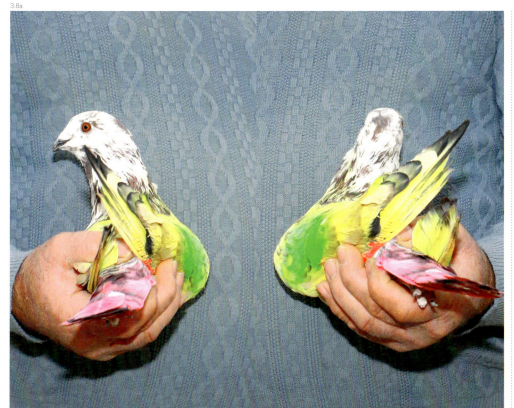

3.8a–3.8b
Ricardo Cases used this image in his photo book *Paloma Al Aire*, a humorous, self-published photo book celebrating pigeon fancying in Spain.

3.8b

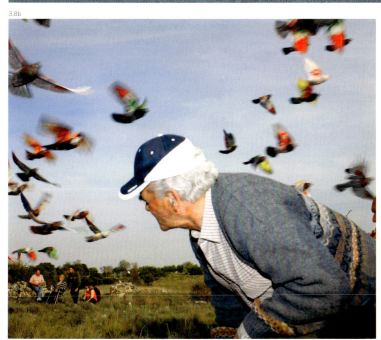

RESEARCH SEBASTIÃO SALGADO

The photographs of Sebastião Salgado are made by the photographer spending extensive time with a community. Salgado's ethical drive is to bring to light the injustices of poverty, oppression and capitalism's relentless drive for raw materials. Unlike his peers, Salgado distributes his work himself through a unique agency, Amazonas Images. www.amazonasimages.com

PROJECT: PRIVATE MADE PUBLIC

'All pictures are very voyeuristic, but ultimately I'm looking at what lurks in my own interior. I make photographs because I want to answer the question of what propels me to do the things that I do But that always remains a mystery.'
Gregory Crewdson

THE BRIEF

As the mediator between your chosen subject and the viewer, representation comes with responsibility. Where does your allegiance lie? Are you happy to fabricate a striking image at the risk of misrepresenting your subject? Choose one of the following themes to explore in more detail:

1 Annotated portrait

Research Jim Goldberg's 'Open See' project, which develops a new form of collaborative practice, where his portrait subjects write their thoughts and responses directly onto the final photographic prints. The result is a text/image piece created by subject and author. Working with a senior family member, shoot in a location linked to his or her childhood, then ask that person to annotate your prints with his or her recollections.

2 Behind the scenes

Irina Popova's intimate study of drug-addicted Russian parents and their young daughter, Anfisa, are intimate and poignant reflections on private moments. Yet, the images tread a fine line between being exploitative or heartfelt social documentary. Working with a close friend, document a conversation between yourselves, developing a sequence of final images that are suggestive rather than cartoon-like.

3 Collaborative challenge

Explore Hellen van Meene's work, she is renowned for her sensitive portraits of teenagers. She works by building trust with her subjects, often prompting them to do a challenge for the camera. The resulting scenarios remove the sitter's crushing self-awareness and perhaps, for a split second, allow the photographer access to an unguarded moment.

Output

Choose a younger family member and devise a simple activity in a domestic setting to occupy their attention while you make their portrait. Aim to create a reflective, contemplative setting.

3.9a

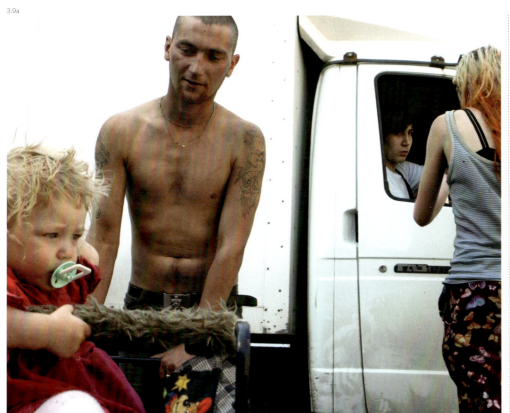

3.9b

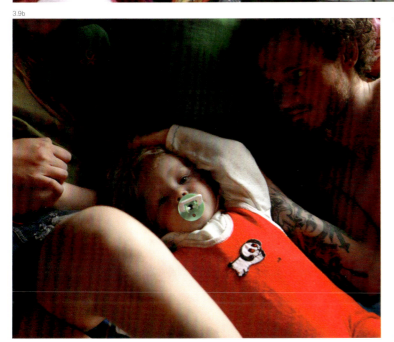

3.9a–3.9b
Irina Popova's study of parents Lilya and Pasha and their daughter Anfisa captures the complex, unfolding story of a young family's battle with drugs.

RESEARCH PHOTOGRAPHERS USING SOCIAL MEDIA

Many photographers use social media to reveal emerging work in progress, or to source help for forthcoming projects. Magnum photographer and book art creator Alec Soth maintains an active blog and you can follow Hellen van Meene on Twitter.

Alec Soth
littlebrownmushroom.wordpress.com
Hellen Van Meene
twitter.com/#!/hellenvanmeene

PROJECT: THE PORTRAIT

'Photography, as we all know, is not real at all. It is an illusion of reality with which we create our own private world.'
Arnold Newman

3.10

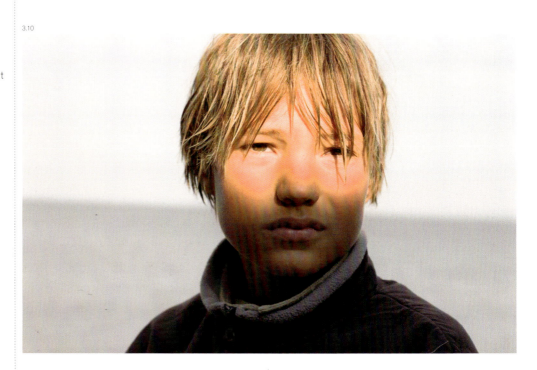

3.10
Gaining trust with your subject is an essential part of portrait photography.

THE BRIEF
Portrait photography is rooted in the collaboration between you and your subject. You'll need to prepare well in advance, sourcing a sympathetic location and arriving with a couple of picture concepts to try out. Devise and develop your own personal response to one of the following themes:

1 Rites of passage
Most family photographs certificate stages of growing and change, whether intentional or not. Photographer Sally Mann created a chronicle of her young children as they emerged from childhood, as do Robin Grierson's evocative 'Family Photographs'.

Choose a family member and think how you can encapsulate their age and lifestyle in a single image.

3.11

2 Dorsality

Surrealist artists such as René Magritte often depicted the figure from behind, creating an enigmatic, over-the-shoulder view. Contemporary photographers such as Lise Sarfati adopt this position, too, isolating the figure in their environment, to create a much more open-ended, ambiguous result.

Choose the most ordinary, mundane shooting location and a willing participant – then see if you can create a tense, unsettling image.

3 Tools of the trade

Portrait photographs made for editorial features in magazines or websites often combine the subject together with a prop, or other recognizable element of their work. Editorial portrait photographer Harry Borden often makes good use of surroundings, be they in a studio or location setting.

Choose an emerging individual in your community and create a portrait image combining prop, location and figure into a visually interesting end result.

4 Hyperreal

Research Loretta Lux's work, she creates eerie portrait images, retouched by her own painterly use of digital manipulation software. Cut away from reality, Lux enlarges and brushes her subjects with such subtlety, it challenges our expectations.

Create a portrait image of a child, set in a timeless location – then see if you can enhance the image using Photoshop.

RESEARCH THE EDITORIAL PORTRAITS OF HARRY BORDEN

Most commercial photographers post their best images online, so prospective clients can see their portfolios immediately. UK-based photographer Harry Borden has photographed many leading celebrities with a fresh, uncomplicated style. www.harryborden.com

3.11
Shooting a dorsal view can create a mysterious and thought-provoking image.

PROJECT: PHOTOFICTIONS

'Photography is about finding out what can happen in the frame. When you put four edges around some facts, you change those facts.'
Garry Winogrand

THE BRIEF

Many practitioners nowadays devise and direct scenarios that are less about observation of the environment, but more about conveying their own personal ideas and concepts. We consume constructed images everyday, from the fashion photo-story through to celebrity portraits and advertising imagery, all produced to hook our attention.

What makes structured reality TV shows so compelling is the blurring between observation and performance. Staged photography promotes a similar paradox: do we believe what we see is for real and if it is fake, does it really matter? Constructed images can carry just as potent a message as an ethical documentary, so your task is to control both the subject and the way it's represented, choosing one of the following themes:

1 The staged environment

Explore the work of sculptor and photographer Thomas Demand, who creates life-sized environments, which are usually bland, corporate spaces. His work plays tricks with our perceptions of fact and fiction.

Using an empty studio space as a starting point, try and recreate a photograph you have found. Put all your effort into creating the set and approach the photography as a documentation task.

2 Living doll

Mannequins, dolls and model soldiers have been used by many artists and photographers to participate as characters in invented scenarios. David Levinthal's use of toy characters, staged and lit in a dramatic manner, create a curiously twilight version of historical events, imbuing the toys with human characteristics.

Source a toy figure and devise a scenario which parallels a real event. Use the toy to play out a role, standing in for a real person.

3 Interspecies

Asger Carlsen's first photo book, *Wrong*, projects a terrifying vision of Western culture. Nightmarish scenarios of animal species mixing with human forms are created with deadpan, but slick digital retouching.

Make a photograph of a person, then try and merge some other life form element into your composition using Photoshop. Aim for an unsettling, subtle end result or your work will look contrived.

Output

Produce two final images with an accompanying title.

3.12

3.12
Lee Avison's
staged photograph
suggests something
is about to happen.

3.13
Richard Tuschman's
image evokes a bygone
era, using focus blur
and colour editing.

3.13

**RESEARCH THE FICTIONAL WORLD
OF BERNARD FAUCON**

French photographer Bernard Faucon's
seminal project 'Summer Camp' evoked
childhood memories, but were played
out by a team of vintage mannequins
sometimes joined by a single human
participant. Arranged in complex
groupings across the beautiful French
countryside of the Luberon and
Camargue, Faucon's vision is embodied
entirely in the pre-photography phase.
www.bernardfaucon.net

PROJECT: MEMORY AND THE ARCHIVE

'Photography has always been a prosthesis for the human eye, in fact for man as a whole, his consciousness, his life.'
Thomas Ruff

3.14
John Stezaker uses old postcards and publicity pictures to create intriguing images, this collage is from his 'Mask' project.

THE BRIEF

For many surrealist artists, the theme of memory provided a playground to exercise unconventional ideas. Nowadays, the archive has become a rich source of interest for visual artists and photographers reworking historic, family and vernacular images into their work. Archive images provide an opportunity to adapt, modify and overlay new ideas about existing matter.

For this project, you'll be exploring how existing images can be reworked and appropriated into new forms. Technology isn't the most important element at this stage, so focus all your efforts on developing an intriguing concept. Choose from one of the following themes:

1 Found photographs

Artist John Stezaker appropriates, or borrows, archive images and makes something new. His 'Mask' series uses picture postcards to overlay publicity photographs of actors and actresses – creating a wonderfully surreal combination. His 'Film Portrait Collage' and 'Marriage' series splice together two different vintage prints to create unsettling collaged portraits.

Your task is to explore the possibilities of combining found photographs. You can either source digital images from the Internet or use magazines. Keep your assembly process simple – the fusion is the most important element of this project, not your software skills.

2 Visual autobiography

Explore Mari Mahr's photographs, which mix together elements from her past 'recalling vague and hazy memories as well as those with great vividness and clarity'. Frequently, she shoots personal artefacts lying over or above photographic prints to create an unusual perspective. For this project, source a range of objects that have an autobiographical link and create a series of still-life images.

3 Memory-zine

The homemade zine is a fast emerging form for distributing photography. Look at Eleanor Jane Parsons' zines, which document her travels and thoughts in words and photographs. Using a simple inkjet printer, scissors and glue, she assembles one master version, which is then colour copied and stapled. For this project, create a simple zine that explores an episode in your recent past using both images and text.

RESEARCH THE NATIONAL ARCHIVES, UK

Explore online The National Archives. It is a huge resource with millions of historical images.
www.nationalarchives.gov.uk

3.14

PROJECT: AFTERMATH

'I never think of my images as a project, I simply live the situations and photograph them; it is afterwards that I discover the images.'
Graciela Iturbide

THE BRIEF

Citizen journalism empowered by the social media revolution has created the conditions for an alternative kind of photo-reportage. Unlike traditional photojournalism where photographers become embedded in the action itself, a more reflective kind of reportage has emerged, identified as 'late photography' by photography writer David Campany. This kind of approach focuses on the aftermath of an event, recording the traces of activity in a detached, almost forensic manner.

This assignment will show you how literary devices such as symbolism, metaphor and connotation can be used within an image to describe more complex themes than pictorialism alone. Devise and develop your own personal response to one of the following projects.

1 Elegy

People and their lifestyles can be a good photographic subject source, but just as much information can be read from facades, redundant spaces and leftover detritus. Look at Simon Norfolk's images of the ruins of Afghanistan, showing the scars of aggression and the reality of living in a post-conflict environment. Your task is to find a safe derelict building, then reveal its former use and purpose through carefully observed details.

2 Crime scene

Paul Seawright's work is noted for describing traumatic events that occur outside the physical frame of the camera or which have happened in the near past. His 'Sectarian Murder' images take texts of atrocities from newspaper reports as a starting point, provoking a return to the same scene several years later. For this task, scour your local newspaper until you find a report that triggers your interest. Visit the scene and make a photographic response to the story and the place.

3 Twilight zone

There's no rule that says you have to stick to telling the truth. Imagined documentary, or constructed imagery, can be just as powerful. Gregory Crewdson devises scenarios that take their visual cue from the world of film. Crewdson's images, show an eerie, twilight suburban world where something has just happened, or is just about to happen. For this project, choose an empty public space at twilight and devise an ambiguous scenario with a group of friends.

Output

Produce a minimum of four final prints of your chosen subject, using captions or introductory text if necessary.

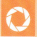

3.15a

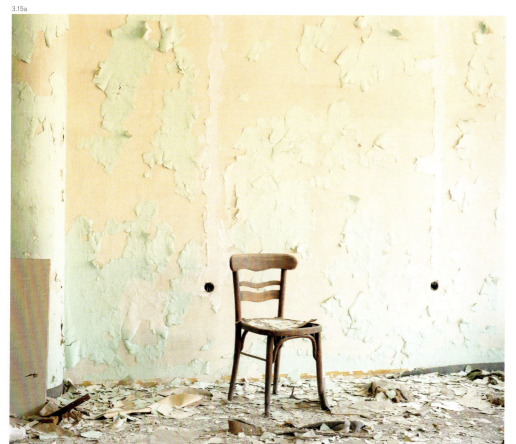

3.15a–3.15b
Colin Dutton's project
shot in Vukovar, Croatia
shows the aftermath
of civil war in civic and
business environments.

3.15b

RESEARCH PHOTOGRAPHERS' CATALOGUES

Many established photographers provide
a catalogue of their photographic
practice through their websites. Here,
you can find their headline projects and
most importantly, read in-depth detail of
their intentions. Research your favourite
photographer's catalogues.

Paul Seawright
www.paulseawright.com
Simon Norfolk
www.simonnorfolk.com

PROJECT: THE SOCIAL LANDSCAPE

'What a landscape photographer traditionally tries to do is to show what is past, present and future all at once. You want ghosts and the daily news and prophecy … It's presumptuous and ridiculous. You fail all the time.'
Robert Adams

3.16

This shows an elegant image from Rinko Kawauchi's photo book, *Cui Cui.*

THE BRIEF

Photographers have been documenting the landscape, not as a pristine example of natural surroundings, but to record the impact of shifting cultural influences. Aside from architectural forms and observational studies of people, the urban landscape is a rich territory for exploration.

In this project, you are encouraged to look beyond the obvious, collecting only those situations that you are compelled to record. When looking through the viewfinder, don't press the shutter if you feel that you've seen or taken the image before. Find and shoot the most obscure things you can find, choosing one of the following topics:

1 Land as metaphor

Explore the work of Edward Burtynksy, which depicts the natural world as vulnerable to the incessant demands of capitalism. His projects on 'Oil' and 'Shipbreaking' describe a declining Western civilization on an epic scale. For this project, seek out a landscape that has altered due to industrialization. This could be a defunct factory, power station or shopping facility. Trace the history of your chosen location through old maps and records to see if this provides an additional back story.

3.16

2 Roadside documents

In *American Surfaces*, photographer Stephen Shore creates a visual diary of his travels along roadside America. In addition to recording building facades and street furniture, Shore also shot recurring items on his trip, such as every meal he ate, the rooms he stayed in and the rental cars he drove. For this project, create a visual diary and fill it with observational images of your community and of your own domestic situation, however ordinary. The narrative you'll create will be an eclectic blend.

3 The democratic landscape

In addition to establishing colour photography as an art form, William Eggleston's choice of subject matter has extended acceptable practice into domestic and vernacular environments. Eggleston's belief that seemingly empty, message-free situations are worthy of scrutiny, has led to some of the most curious and arresting images ever made. For this project, visit a town or city environment on an empty Sunday morning. Make a collection of 100 or so images, shooting only what you've never photographed before.

4 Domestic landscape

Rinko Kawauchi's sensitively observed work gathers together disconnected elements of her daily routines. Shot with an eye for the poetic and minimal, Kawauchi's work has an unconventional pastel-colour register.

Output

Make four final prints from your chosen project, together with an introductory statement.

RESEARCH THE EGGLESTON TRUST

This excellent online resource chronicles the highly individualized output of William Eggleston. Here, you can see how different themes and concerns are developed into artist's books, portfolios and books.
www.egglestontrust.com.

3.17
Simon Carruther's quirky observation of a tree in a front garden in seaside Britain.

3.17

PROJECT:
FASHION STORY

'I feel I'm anonymous in my work. When I look at the pictures, I never see myself; they aren't self-portraits. Sometimes I disappear.'
Cindy Sherman

3.18

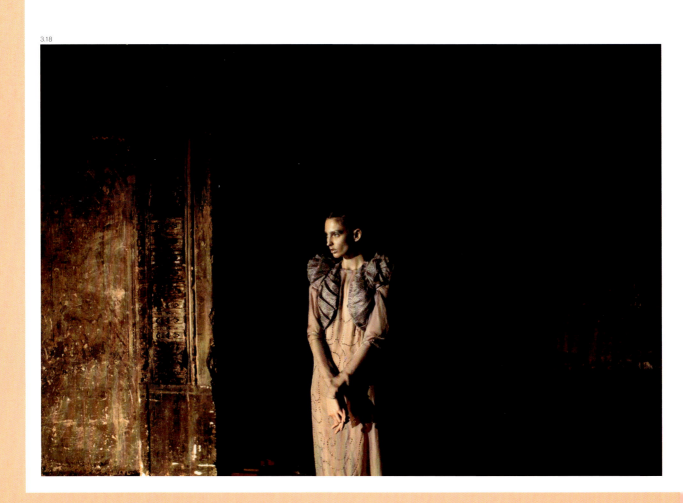

THE BRIEF

The best fashion stories play out an entirely convincing tale which forefronts the products and lifestyles we are being encouraged to buy. Your task in this project is to create a plausible story or an event in a supportive location using characters, props and costume. Shoot the story through one of these options:

1 Home alone

'The New Life' is Lise Sarfati's poignant study of young women set within the confines of their domestic or local environment (see www.lisesarfati.com). Mostly looking away from the camera, Sarfati's subjects are captured in a silent reverie – a moment of isolation and perhaps, vulnerability. Your task is to work with a friend in an evocative setting, to create a feeling of loneliness, contemplation or daydreaming.

2 Faded gentry

Research the work of fashion photographer Deborah Turberville, in particular the way she uses the set, costume and texture. Her stories are often staged in crumbling manor houses using dancers in floaty ephemeral costumes. Your task is to source a grand location and devise a scenario with a group of collaborators. Work with fashion, acting or dance students if possible – as their collective response will make your task that much easier.

3 Simplicity of style

We can project a tighter narrative by shooting our story as simply as possible using minimal sets and props, but without skimping on styling. Look at Alexander Sainsbury's fashion photography, which has graced the pages of all the leading fashion magazines with his pared-down approach. Even slight fall-offs in focus look luxurious in his work. For this project, work with a friend and try to capture their unique individuality using empty spaces and clean, brightly coloured surroundings.

3.18

Paulo Pellegrin has created an atmospheric fashion story by locating the model in a grand but faded location at the Théâtre du Bouffes du Nord in Paris, France.

RESEARCH FASHION MAGAZINES AND FASHION BLOGGERS

The best way of seeing what's 'now' in fashion photography is to look online at trendsetting magazines, such as *Dazed and Confused*, *i-D* , *Wonderland* and *Garage magazine*. Fashion bloggers, many of whom are photographers as well, really influence the fashion scene, too. Their content is free to access and is often refreshingly more homespun than slick. Good bloggers to check out are:

Susanna Lau, creator of www.stylebubble.typepad.com
Scott Schuman, creator of www.thesartorialist.com

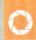

ASSIGNMENT:
A SUSTAINED
PERSONAL STUDY

'When you spend more time on a project, you learn to understand your subjects. There comes a time when it is not you who is taking the pictures. Something special happens between the photographer and the people he's photographing. He realizes that they are giving the pictures to him.'
Sebastião Salgado

THE BRIEF

Develop one of the previous projects into a more ambitious, long-term study. Your task is to explore further an area of your interest through a self-directed project over a longer period of time, typically three weeks. Think of a subject that you already have a connection with, it could be a friend, a place from your childhood or a story you have been told.

Research Valerio Spada's award winning book *Gomorrah Girl*, which chronicles the accidental killing of a teenage girl, Annalisa Durante, in Naples, Italy, during a feud between rival Camorra sects. Spada photographs the people left behind in the tragedy, then interweaves his images with photocopies of the police forensic report to create a story told in two very different voices.

You must produce the following:

1 A journal containing a weekly account of your photographic activity, including reflections and commentary after each shoot. Make contact prints of all the images you take, marking up all those that have the potential to make the final selection.

2 Research photographers who have tackled similar projects, placing examples of their work alongside your own.

3 A statement of your intentions (250 words maximum) identifying your thematic interests and how you propose to treat the issue or story.

4 A written reflective evaluation describing what you have learned during the project.

5 Eight final inkjet prints, printed up to form a display.

3.19

3.19
Rob Wilson's collection
of boxes shows an
assortment of finds.

CHAPTER 4

PROJECT DEVELOPMENT

Developing a considered approach to your photographic project before you venture out will pay more dividends than luck alone. This chapter will introduce you to the fundamentals of planning and researching your ideas and encourage you to treat the process of shooting as a research exercise. The best projects are those that develop an individual interpretation of the world, however, this is rarely achieved without sustained shooting, reflection and critical awareness. Stretch your practical work across different shoots and ensure that you reflect fully on each stage before deciding on the next step. Don't be afraid of changing direction as your project develops or if your research unearths a different way of thinking. Some of the images shown in this chapter have not been taken using a digital camera but are included because they are of historical importance or the creative skills used are as relevant to digital photography as to analogue photography.

'I only ever take one picture of one thing. Literally. Never two. So then that picture is taken and then the next one is waiting somewhere else.'
William Eggleston

4.1

Thomas Hoepker's witty image shows the Giza Pyramids with army of 'trash people' sculptures by artist HA Schult.

DECIDING ON THE SCOPE

There's every reason to base your first projects in the environment you know best – or with the people you are friends with – as you will have already spent time thinking and reflecting on it.

WHAT MAKES A PROJECT?

Blockbuster photographic projects, such as Edward Burtynsky's 'Oil', are conceived and realized across different continents and involve a supporting cast of production and research assistants. Vast in both scope and printed outcome (the exhibition prints were wall-sized), 'Oil' crystallized the tipping point of capitalism's dependence on fossil fuel – a big story reaching across different timelines and cultures. Yet, you could shoot a documentary in any rundown estuary town in Europe and make the same point.

The hardest aspect of any project development is deciding where the boundaries are. Some of the very best photographic studies have been made in micro-environments. Josef Sudek's beautiful studies of flowers and glasses of water were shot on the same window sill in the same Prague studio over a period of 30 years. Shooting in exotic locations is easy, but making work in a mundane environment is a challenge.

4.1

DEVELOPING A PERSONAL PROJECT

Most photographers develop an idea for a personal project while shooting something else. The very activity of shooting and reflecting on your results can suggest fresh and compelling ideas. If you're stuck for an idea, carry your DSLR camera with you each day for a week and shoot a visual diary of your activity. When reviewing your results, mark the best shots and see if you want to explore any aspects further.

4.2

HITTING UPON AN IDEA

All photographs deliver some form of narrative, which can be delivered in lots of different ways: straight storytelling, reportage, fantasy, pseudo-scientific to name but a few. First, you have to decide what story your project will deliver. Is it about a place, human behaviour or a fictional character? Or is it about a previously unrevealed cultural practice?

HOW BIG, HOW LONG, HOW MANY PRINTS?

You can communicate a complex idea in a single image and explore its themes sensitively in four or eight final prints. Limit your time to four weeks, as this will give you ample time to make an initial test shoot, two or three main shoots, and a final contingency shoot should anything go wrong.

PRACTICALITIES

Start out by working on a project within reach, both financially and geographically. Work out the logistics of travelling to your shoot location and any other costs involved. Keep reviewing your images as the project progresses and don't be afraid to change course if a variation on your idea presents itself – that's what practice is all about.

4.2
Emma Lavender's altered book describes the threat of living in an urban environment.

4.3

DEVELOPING YOUR AUTHORIAL VOICE

All photographers position themselves as a kind of mediator between the subject they shoot and the audience that sees the work.

It's impossible for you as an author to remain invisible in your work and the notion of remaining impartial is a myth. Everything you shoot and record has been 'processed' and has your 'fingerprint' on it. For some photographers, this very processing is overt, visible and so embedded into the work that it becomes a hallmark of their approach. For others, the role of mediator becomes transparent and only recognizable through subtleties that require the image to be read or unpicked. As you progress through your early photographic assignments, you'll be developing your own voice and deciding where you fit in. Together with your own personal tastes, politics and belief system, you'll develop an affinity with one or more of the roles discussed below.

Reportage work holds sacred the notions of impartiality, fact and accuracy. Many eyewitness images become evidence, indexing significant world events. It is this very power that tempts unscrupulous photographers to fabricate situations, presenting fiction as fact.

PHOTOGRAPHER AS ARCHAEOLOGIST

Many non-events can also comment on deeply significant cultural issues, especially aftermath or off-camera reaction. In this mode, the photographer becomes a kind of retriever or beachcomber, sifting through the fabric or leftovers of a culture. This kind of work can be more reflective, gathered in quantity and decoded as a series or collection. Photographers working in this mode spend time unearthing, cataloguing, and preparing visual specimens for later contemplation.

4.3

Tim Hetherington (1970–2011) renowned for his fearless coverage of modern conflict, observed US soldiers asleep for this poignant study in Afghanistan.

PHOTOGRAPHER AS EYEWITNESS

Most of the still images used to represent news and features are captured by photojournalists, reportage and documentary photographers, who have positioned themselves as eyewitnesses to significant events. Eyewitness photographers often make themselves as invisible as possible, seeing their role as channelling the event rather than imprinting any visual or stylistic recipe on the image.

PHOTOGRAPHERS TO RESEARCH

Jacob Riis
Tim Hetherington
Tom Wood
Bernd and Hilla Becher
Martin d'Orgeval

PHOTOGRAPHER AS FABRICATOR

Some practitioners refuse the opportunity to be a conduit for cultural messaging, positioning themselves as artists, inventors and makers instead. Working as a fabricator, your own visual ideas and tendencies will be very visible in the work, which will be just as much about you as the subject you investigate.

The material properties of your work will be important to you; you'll want to manipulate printing paper, perhaps annotating or collaging many different elements together. You'll want to construct the very images that you shoot.

4.4

4.4
Hilary Walker's still-life
image is carefully crafted
using a pastel-coloured
palette and period items.

PHOTOGRAPHER AS FACILITATOR

Some of the most interesting photographic projects are devised and undertaken by a group of collaborators rather than delivered by a virtuoso artist. In very simple terms, portrait photography is a collaborative act – where consent and direction are traded between the two participants. At the other end of the scale, participatory practice involves the artist/photographer working as a facilitator of the work, erasing all evidence of their individual 'fingerprint' from the final images. Collaboration delivers results from social interaction; you'll need to be open-minded and able to bounce ideas off and respond to changing situations.

4.5
Toumpanos Leonidas' photographic collaboration with a dancer was staged in an atmospheric post-industrial location. Rather than storyboarding such a shoot in advance, you could experiment with what might emerge from a collision of place, person and accident.

PHOTOGRAPHERS TO RESEARCH

JR
Anthony Luvera
Josh Cole
Ryan McGinley
Wolfgang Tillmans
Danny Treacy
Stephen Gill

DEVELOPING CONCEPTUAL STRATEGIES

4.6
Hans Eijkelboom's
collections when presented
in print form, create
a typology of fashion
behaviour.

Without a framework, many photographic projects would spread out, meander and spiral off into irrelevant territories.

WHY USE A STRATEGY?

A good project framework allows you to define both the scope and limits before starting your exploration. Conceptual photography is often described as a kind of practice subservient to the idea, sacrificing craft and subjectivity. Conceptual frameworks, though, have been used by many photographers whose work is anything but cool and detached.

COLLECTING AND SEQUENCING: HANS EIJKELBOOM

Often described as a conceptual documentary photographer, Eijkelboom devises schemes that give rise to photographic projects. Following in the footsteps of street documentary photographers, Eijkelboom's sequences and collections suggest themselves during the very act of shooting, rather than as a prepared and planned idea. His book, *New York by Numbers* (2009), features photographs of passers-by wearing numbers 1–100 on their clothing. The framework itself is a snappy idea, but most importantly, it gives rise to an experiment that allows Eijkelboom to create a cross-sectional observation of street fashion. It's the idea that cements the images together rather than a photoessay narrative.

4.6

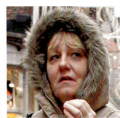
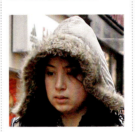

4.7

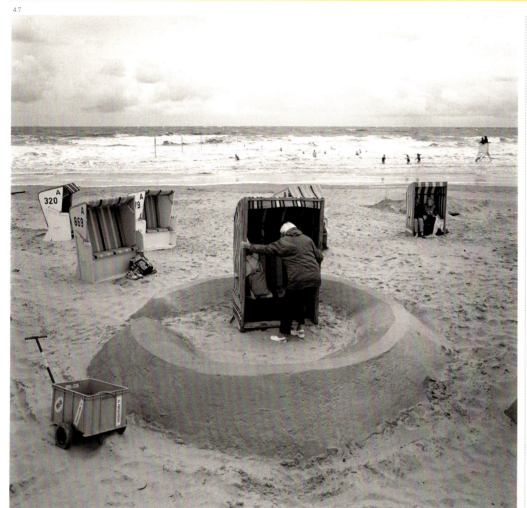

4.7
German Bight: Sunday, 27 August, 1995

Northwesterly veering northerly, five to seven, decreasing four for a time in east. Squally showers. Good (from 'The Shipping Forecast'). Although Mark Power's 'Shipping Forecast' project was shot on film and handprinted, his underpinning conceptual structure is appropriate for all photographers.

UNIFYING THEME

Taking the BBC's Radio 4 maritime weather forecast as his starting point, Mark Power visited the mysteriously named locations, invisible to all radio listeners bar the seafaring community. Each location in his collection 'The Shipping Forecast' effectively became a blank canvas for the photographer, relieved of the duty to devise a coherent narrative between different sites.

THE BRADFORD GRID AND THE PORTLAND GRID PHOTOGRAPHY PROJECTS

Using an Ordnance Survey map as a simple grid reference starting point, these projects allocate each square of the terrain to individual photographers who build a personal response to that area. The concept provides a starting point rather than a systematic 'recipe' that defines the work and allows a wide range of collaborators, both professional and amateurs, to participate (see www.portlandgridproject.com).

DEVISING A STATEMENT OF INTENT

All bodies of visual art are best presented with an accompanying artist statement outlining the aims of the work.

For visual rather than literary practitioners, creating a written statement that encompasses their creative aims can be a difficult thing to achieve. In your early self-directed projects, your own unique approach will be emerging rather than established, fluid rather than fixed. Statements at this stage of your career are developmental in tone rather than authoritative. And, perhaps most difficult of all – you might think in images rather than words.

Once you've chosen a theme to work with, the best way of approaching this essential part of project development is to start generally then edit to the specifics. Conversely, most artist statements are refined and polished at the end of a project rather than the beginning, so there's no need to tie yourself to an idea that you might eventually change.

STEP 1: WRITING A PRACTICE NARRATIVE

Start by writing a descriptive passage after each shoot reflecting on what you have achieved. Write this as if you were explaining your work to a non-visual art audience. The narrative can describe what you've found, what conclusions you've made and what possibilities have emerged.

STEP 2: PROJECT DESCRIPTION

Towards the end of your project, pull together the pertinent sentences from your different practice narratives and write a paragraph about your project. Try to identify the wider cultural issues emerging in your work; this is best achieved by showing your work to others and engaging in feedback. Although your practice is the engaging bit for you, focus on the project narrative, as the purpose of these words is to engage others in the story.

4.8a

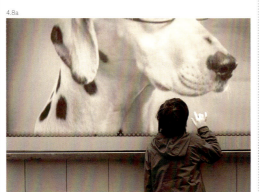

4.8b

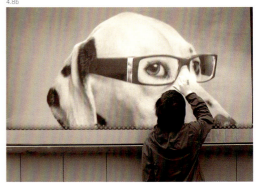

STEP 3: SHORT PITCH

From your project description, précis your words into a single sentence. Longer descriptive passages sometimes repeat the same information, so only include the facts. It's not important to reference sources or inspirations here, just a single sentence will suffice, the kind of short, sharp information that you could pitch at a curator or commissioner while travelling in a lift. This will summarize the subject, tone and purpose of the project. It could look like this: 'Paper documents: remnants of a Victorian mental asylum.'

STEP 4: PROJECT TITLE

Your final task is to reduce your short pitch into a two- or three-word title. See if you can trace the following titles to their respective photographers: 'Film Stills'; 'The Democratic Forest'; 'Go-Sees'; The Destruction Business'.

PROJECTS TO EXPLORE

Flip

The London Independent Photography members' magazine, Flip, showcases projects from emerging photographers accompanied by short artist statements. www.londonphotography.org.uk

Source: Graduate Photography Online

This is a very useful online archive of graduate photography students' portfolios, which is presented each year to accompany degree shows. Each student has four or five images alongside an accompanying statement, pitched at interested curators and commissioning agents. www.source.ie

4.8c

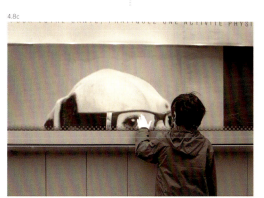

4.8a–4.8c
What kind of statement was the photographer making with these images?

4.9
Walker Evans both
photographed and
collected examples
of vernacular signage.

DOING THE GROUNDWORK

Making effective research into your chosen project is a prerequisite of good work; choose to ignore this and your work will look like that of a tourist.

SOCIAL DOCUMENTARY

In a fast-moving world, circumstances change our environment with increasing speed and novelty. People and their lifestyles can be good photographic subject sources, but just as much information can be read from facades, signage and evidence of the personal touch. Great documentary photographers, such as Walker Evans, scoured small-town America to find hand-painted signs, house fronts and signs of life to describe the unique character of those living through the harsh conditions of the American Depression years. Signs and symbols can be very evocative of local culture, beliefs and personalities that could never be captured in a portrait photograph.

DIGGING INTO HISTORY

All towns and cities have their fair share of historical symbols that go beyond those found in a tourist guidebook. Local museums and libraries are good sources of inspiration, as they will have excellent records of life under previous generations. Many keen documentary photographers recoup some of their costs by selling their work to local libraries and museums for their archives. If you are interested in local history, photography is an excellent medium for recording the diminishing signs of the past and preserving them for the future. Online archives, especially census data, can provide an intriguing backstory to your project.

Using Google Earth

Now that most of the built environment has been captured and presented on Google Earth, you can scope out a location from the convenience of your laptop. Although there's no substitute for visiting and test shooting a location, Google Earth is worth including as part of a general mapping exercise.

Psychogeography

For those projects involving a reflective exploration of the environment, it's well worth investigating the psychogeography approach. It was defined by Guy Debord (1931–94) who developed the notion of exploring the urban environment through a 'dérive' or drift. Mixing the imaginary with the actual, writers such as Iain Sinclair project an alternative interpretation of the urban terrain, beyond the purely observational.

Mapping ideas across different media

Many project ideas have already been shared by creatives working in media other than photography. Filmmakers, visual and performance artists, and writers all work with the same proposition: to create narrative work that engages an audience. Your task is to find like-minded practitioners that link to your own project idea, as they will give you an invaluable source of research information.

4.9

PHOTOGRAPHY PRECEDENTS

At a very superficial level, researching photographers that link to your own practice is easy. It's not difficult to find common ground when you're tackling the big genre subjects, such as landscape or the urban environment. However, proper research is more than just matching images, it's about unearthing the less obvious and more thought-provoking work of others.

KNOW YOUR CLICHÉS

Photography, like any other visual art form, is haunted by repetitive, recurring visual clichés. It's important to be aware of these; they are a sign of lazy practice. Images that trade on this lowest common denominator (one could argue that they succeed because of it) can be found in microstock websites.

In commercial stock photography, visual clichés abound. To test your awareness, visit one of these websites and enter an emotionally charged word, such as 'despair'. What'll appear will be a series of illustrational photographs that trade on an over-simplistic interpretation. Enter another word, but this time try and guess what the images will look like before you press 'Search'. Commercial stock imagery depends on accessibility and ease of interpretation, but could be viewed as the equivalent of shopping centre 'muzak'.

APPROACHING PHOTOGRAPHY RESEARCH

Although there are plenty of photographic images that we can access online, the best work is produced by thoughtful, critical photographers who have decided to contribute something different. Those who approach their work as a technical exercise or purely in the pursuit of scarcity, which can include keen amateur landscape and wildlife photographers, do so within boundaries firmly established by others. It's important, therefore, to seek research sources away from enthusiast websites and amateur photography magazines.

Scholarly photography publishers, such as Aperture, Steidl, Phaidon and other imprints, will provide you with plenty of source material to start your individual photographer searches.

4.10

4.10
Josef Koudelka
captured the despair
of the residents of Prague
during the Soviet invasion
of Czechoslovakia in
1968. Research his work at
www.magnumphotos.com.

PARALLEL SOURCES
In addition to accessible individual
monographs, historical collections and curated
exhibition catalogues, there are several parallel
research sources to consider.

VERNACULAR PHOTOGRAPHY
Since William Eggleston's use of colour
photography, there has been a growing interest
in vernacular photography. Most images are
produced by non-professionals without any
artistic pretensions, yet these unique works
are often evocative and thought-provoking.
Photo booth portraits, found photography and
re-photographed banal imagery can be as
unsettling as a highly staged fine art image.

USEFUL RESOURCES
Books on found photography, such
as *Photo Trouvée* (Phaidon, 2006).

VERNACULAR SOURCES
Kesselskramerpublishing.com
including their droll *'Useful Photography'*
series, recycling the blandest imagery
ever produced.

FOUNDMAGAZINE.COM
A good source of found photography,
often defaced or damaged – submitted
by a network of contributors.

EXPLORING THE ARCHIVE
The politics of public access has led to
many archive collections of photography
becoming available online. Many great
collections and resources are available
online, including the US Library of
Congress, and the Imperial War Museum.

CONTEMPORARY NETWORKS

Being connected to the right photography networks is an essential part of developing your own practice.

In addition to learning through your practice while studying photography at college or university, it's important to keep up to date with the contemporary scene. You can follow most of the following organizations and publications on Twitter, Facebook or by getting onto their email call-outs. Most of the opportunities for emerging photographers, such as jobs, internships, commissions and competitions, are announced in the specialist photography media, so it's important that you hear at the same time as everybody else.

INDUSTRY ORGANISATIONS

Creative Skillset is part of the UK government's Sector Skills Councils and it offers vocational advice. It provides some guidance for photographers in its photo-imaging section.. Creative Skillset publish impartial guidance on careers, qualifications, and training and publishes the National Occupational Standards for photo imaging, a list of skills that the industry requires aspiring entrants to possess (see www.skillset.org).

The Association of Photographers is the UK's leading professional photographers' organization, providing a range of member benefits including business advice, awards and exhibitions. The AOP's Assistant awards programme is a renowned route into the industry for student photographers (see www. home.the-aop.org).

SOCIETIES
The American Society of Media Photographers

The ASMP is a society that promotes and protects the best interests of its photographers, most of whom work in the editorial field. The society provides resources and guidance to support all stages of a photographer's interaction with their client, from a detailed digital photography best practice workflow to advice on pricing and licensing your images (see www.asmp.org).

Royal Photographic Society (RPS)

The RPS was established in 1853, and offers photographers across the world the chance to become accredited in a wide range of photographic fields, such as wildlife, architecture and documentary. The RPS has several regional subgroups, which meet on a regular basis for mutual support, training and exhibition and publication projects (see www. rps.org).

London Independent Photography (LIP)

A community-based organization run for emerging photographers based in London and England's South East (UK). LIP has a monthly magazine displaying members' work, workshops and exhibitions, and several satellite groups who meet informally to support each other's practice (see www. londonphotography.org.uk).

RESOURCES AND FESTIVALS

Contemporary practice publications

For an insight into the latest contemporary photography, both *Source* and *Photoworks* magazines showcase challenging work alongside critical commentary. Photography blogger JM Colberg's unique website 'Conscientious', reveals a wide range of new work including portfolios, photo books and exhibition reviews.
www.source.ie
www.photoworks.org.uk
www.jmcolberg.com

Photography trade journals

The British Journal of Photography is the UK's leading publication for professional photographers, featuring sector news, equipment and exhibition reviews and business analysis. *Photo District News* (PDN) is the equivalent publication for the USA, based in New York.
www.bjp-online.com
www.pdnonline.com

Photography festivals

Les Rencontres d'Arles Photographie

The annual festival of new and unpublished work located in Arles, France.
www.rencontres-arles.com

Paris Photo

A heady mix of historical and contemporary work in print and publication. It can take two days to look around.
www.parisphoto.fr

Visa pour l'Image

The international festival of photojournalism takes place each year in Perpignan, France.
www.visapourlimage.com

International Fotobook Festival

The annual exhibition of curators' best books of the year, plus the innovative Dummy Book Award for aspiring photographers wanting to get into print.
2012.fotobookfestival.org

ETHICAL AWARENESS

As soon as you take the lens cap off
your camera, you'll be confronting
a wide range of ethical issues
surrounding your role in the
mediation of your chosen subject.

4.11

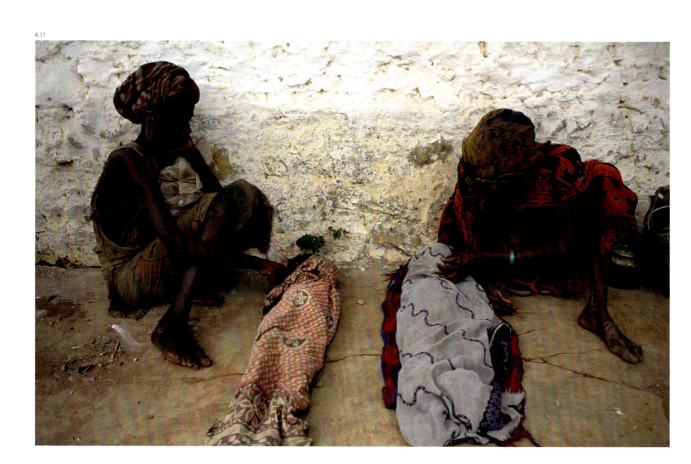

4.11
When photographers take images of people in tragic circumstances they can face a moral dilemma – whether to intrude on someone's grief or to show the reality of a terrible situation. Chris Steele-Perkins' photographs of the famine in Somalia revealed the tragic consequences of those affected by starvation.

POLITICS OF REPRESENTATION

Equipped with a device that can easily shape others' perception of reality – the camera – the primary responsibility of a photographer is to consider how they are representing their subjects. To be framing and capturing means that you are controlling the way information is collected, and this is further controlled through editing and post-production. It's easy to exclude vital information from your viewfinder when shooting, and this is even more tempting if it contributes to a stronger message or more graphic result.

At the start of a project, it's important that you define your own role in this process. Are you a dispassionate observer or a passionate participant? What kind of manipulation do you engage in? Do you ask permission from those that you record, or do you think every photographer has the right to observe surreptitiously? Does the process remain invisible to the subject, or can they collaborate in the creation of the final works? Is it right that you have the power to say how another person is represented?

REPORTAGE INTEGRITY

Narrative, storytelling images that are distributed through news and feature agencies depend on the professional integrity of the photojournalist and their host agency. This provides assurance and reliability to picture editors that the events really did happen in front of the lens, rather than being staged or, even worse, digitally altered. The history of photography is littered with instances of fiction being passed as fact – the temptation to manipulate, placing financial reward at the expense of integrity can be too great for some practitioners.

VIEWER OR VOYEUR?

Many of the most infamous war and famine photographs were captured with some collusion on the part of the photographer. Should you benefit from the suffering of others? Should you step in to save the victim, or is your role that of a messenger? At what stage does reportage become voyeuristic? Does the image contribute to change, or does it diminish our own tolerance for shock? Do famine images really promote political change, or do they merely increase our own feeling of helplessness?

WHAT STANCE WILL YOU TAKE?

Most images created for editorial and advertising purposes are constructed rather than observed, and within fine art photography practice you are free to adopt any role that suits. Imagined documentary, constructed reality or devising as a group, all provide an exciting blend of real and simulated. Defining how you've approached your project is the key – don't be tempted to pass it off in any other way.

STARTING A VISUAL JOURNAL

The best journals are active workbooks where ideas are first formulated and trial work can be explored.

For many students of photography courses, the research journal has become an unsophisticated repository of second-hand content acquired from the Internet. The best journals however are not those most crammed with information, but the ones that describe a journey, fusing practice and research together and most importantly, regularly added to.

SHAPES, FORMS AND EXTENT

Good journals can be made using any kind of sketchbook or notebook, but bigger, spiral-bound folders present extras opportunities to interleave large contact prints and proof prints. Bigger journals also allow you to see more side by side in a double page spread, giving you the chance to compare and contrast different variations of the same image. A good shape for a visual journal is an A3 landscape format folder, which can be easily added to during your course.

WHAT GOES INTO YOUR JOURNAL?

Each project you tackle will usually start with a written brief. A good way to approach your initial responses is through a mind map, plotting out your thoughts and ideas. The mind map can be the starting point for your project plan, before you identify your shooting sources. As your work progresses, it's important to include sheets of contact prints each week, each annotated with your initial responses or selections. Many photographers reference their work by indexing each shoot with a number or the date. As you reflect on your practical work, it's important to move beyond the purely descriptive commentary, speculating on possible messages and meanings developing in your work. It's not essential to have all the answers, or to think there's a 'right way' of unpicking your practice.

INTERLEAVING VISUALS

Through feedback from your peers or tutors, the work of other visual artists and photographers will be suggested – and following this up is an important part of your project development. With most kinds of visual practice, there will be precedents to consider alongside your own work; referencing these evidences your academic ability and may also trigger further ideas for your next shoot. It's easy to find superficial links in subject matter, so spread your research net wider, sourcing contemporary journals and galleries rather than history books.

REFERENCING PHOTOGRAPHER'S WORKS

Once you've got a precedent to research, it's easy to find obvious images on the Internet, but much harder to make an informed choice of lesser known works that have a more direct link to your own studies. Collecting and editing through another photographer's work in a questioning rather than accepting manner is a form of curating – it helps you to develop critical awareness.

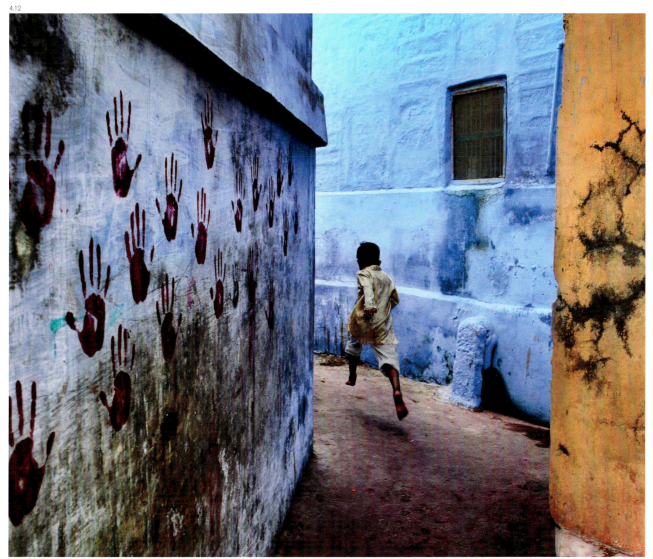

4.12
Steve McCurry's
photographs, many
taken in Asia, are
fantastic examples of a
photographer undertaking
a visual journey that delves
beneath the ordinary.

TEST SHOOTING

Don't expect to score instant results
every time you shoot; preparation,
persistence and an open mind will
always pay dividends.

4.13

Many studio photographers,
such as Oscar Lablaiks,
control the capture and
initial processing through
a computer tethered
to the camera.

4.13

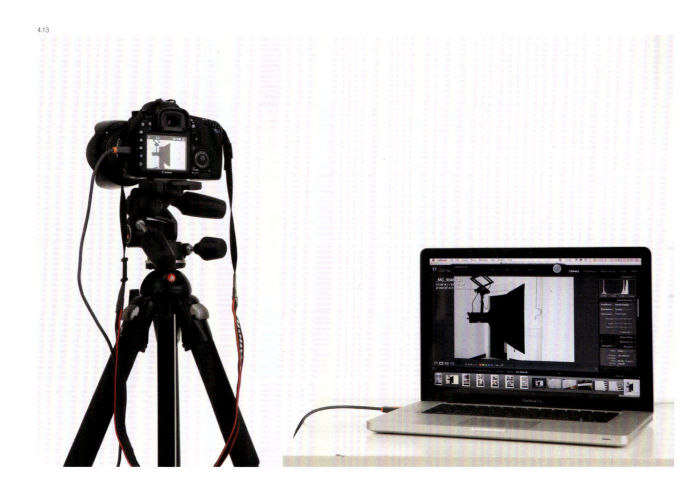

PREPARATION FOR STUDIO SHOOTING

Photography lets us contemplate later events that happen in a momentary flash. These events are not just restricted to high-speed action, a sporting moment of glory, or the sight of a rare animal in the wild, but can be everyday occurrences. The luck factor can never be overestimated, but successful photographers make their luck by being ready and in the right place at the right time. It's essential that you approach each shoot, be it studio or location based, equipped with the confidence to focus on the image, rather than worry about technique. For each new studio shoot, successful photographers make a lighting test a top priority.

If you've created a room set or complex scenario in the studio, you need to do a test shoot to check lighting and depth of field, just so you can relax about the visual consequences of your set-up. Many studio photographers shoot with their DSLR camera tethered directly to Lightroom, using an assistant to check lighting, exposure and focus on a high-resolution monitor as the shoot progresses.

The most important skill required by a studio portrait photographer is the ability to create a relaxing atmosphere conducive to good results. All but the most experienced photographic models are nervous and stiff when faced with glaring studio lights and an array of daunting technology. Music, a well-heated room and an unhurried approach will help, and if you can share the shoot with your model by outputting your DSLR to a video monitor – it'll feel like a collaboration rather than an ordeal.

ON LOCATION

It's impossible to foresee all the shooting opportunities that present themselves during a location shoot, so you should be prepared to approach each event with an open mind rather than a shopping list of preconceived ideas. Roy Stryker was the American Government's Farm Security Administration picture editor during the Depression era in the 1930s, and famously provided his photographers with lists of shots to gather before they left the building.

Never try to score final shots in a single shoot, as you won't be able to respond to unplanned ideas that have emerged. If you are shooting a narrative piece, this works best when the sum of the parts are greater than any single image. Aim to capture your subject with a broad brushstroke, shooting details and incidentals, as well as the main elements, to give a flavour to your project.

It's difficult to reflect on your images while out in the field, so it's important to respond to any instinctive feeling you have. If you feel that you've taken the picture before, don't press the shutter.

The best location photographs are made when the photographer has developed an in-depth understanding of the cultural environment rather than restrict his work to a purely pictorial study. In practice, this means researching your subject, a process that will suggest many more potential locations than a tourist map will ever do.

WORKING IN A GROUP

Part curator, part facilitator, part
producer – working in a group context
can generate exciting results that would
have been impossible to create alone.

4.14
This picture composed by
the French street artist
JR is part of a community
project called 'Through
A Mother's Eyes,' which
involves members of the
economically distressed
Bronx neighbourhood in the
US. JR, a recent TED prize
winner, has staged similar
projects around the world
that look to transform high
crime and impoverished
neighbourhoods into
spaces for street art
combined with the
celebration of community.

4.14

COLLABORATIVE PRACTICE

There continues to be many effective creative partnerships working within photography – where the group rather than the individual determines the agenda. Many collaborative projects are designed to engage people in the community to participate in the creation of a piece of work. As a photographer, you'll be swapping your traditional role of lone artist and privileged observer for a different way of working. Collaborative projects can lead to group exhibitions, events or publications and are a good way to generate momentum in your early career. While most of your art and design education will be preparing and refining your individuality, collaborative practice does the opposite. Linked to the ever-important evidence of community participation and engagement, arts organizations support projects that demonstrate such footfall.

PARTICIPATORY PRACTICE

French photographer JR, a former graffiti artist, has devised a unique approach to collaborative practice, using volunteers and crowd-sourcing images from all corners of the globe. JR's practice uses photographic portraits to create billboard-sized posters, which are then pasted to unconventional sites. JR's projects are designed to empower those who have little say in developing countries, or to promote community cohesion in troubled places. JR's role in all of this is as a curator of an open submission exhibition – the artworks are not produced with the same purpose as an exhibition print – they are part of an ongoing awareness campaign.

NETWORKED ART

Networked art and independent publishing, under the influence of socialist ideology, emerging technology, alternative distribution and artist collaboration, further developed the notion of the independent photographer. While the focus of networked art is less about production and more about the manner of its distribution, many independently published collaborative photo books and zines developed a new visual style by using cheap reprographic processes.

The seminal photo zine *Tell mum everything is ok* (see www.tellmomeverythingisok.tumblr.com), has an open submission, where interested photographers worldwide contribute their work to a themed issue. This publication, along with many other zines, is the result of a collaborative editorial policy where final content could not have been foreseen. These low-tech publications also tip photography in a different material direction, away from the obsessive litho-printed books, into transient, ephemeral and tactile publications. Self-publishing is now a reality for all photographers, with many choosing non-traditional materials, such as newsprint.

MAKING A PRACTICE BLOG

Although basic blogging websites were initially the domain of would-be writers, more sophisticated blogging sites have enabled artists to create online journals and galleries of their work.

Many visual artists and photographers nowadays document and reflect on their practice using a blog. The advantage of creating a blog is that you don't need any special web-design software or web-authoring skills – the blog is accessed through a simple web browser and all editing tools are found within a simple control panel.

Blogs are a useful addition to a physical journal, as you can easily hyperlink research alongside your own practice to create a rich source of evidence for your studies. Although blogs exist in the public forum, you can decide to share your reflections only with a select group, or join a network of like-minded photographers for feedback.

Practice blogs are becoming part of the selection process for university application, and provide a good way of demonstrating your activity to potential clients and collaborators.

Step 1: Register
To register and choose your free blogging web address go to www.wordpress.com and sign up. Once you've logged in, go to your Dashboard and click on the Appearance button. The appearance of Wordpress can be enhanced by choosing one of the free templates, called Themes. In a separate browser window, visit http://theme.wordpress.com and enter the word 'photo' into the search field, as shown.

4.15
Wordpress is a free blogging and publishing software often used as the backbone of Content Management Systems for large websites. The website Wordpress.com provides a free hosting service for bloggers, with pre-installed software and templates ready to use.

4.16
Blogs work best when the content is clearly divided into different sections, rather than just archived by date. For your practice blog, you could create different sections for projects, written research, visual sources, material tests and critiques.

4.15

4.16

Step 2: Add your content

Now, you're ready to load in your images and words. Don't worry if you do not have a clear flow chart ready, you can re-order your content at any stage. Each new entry to a blog is created by making a post, so first click on the Posts>Add New button. To add an image, click on the tiny icon to the immediate right of the Upload/Insert text 9S (see image 4.16). Follow the instructions for the upload, ensuring that you select Full Size to display the image in the post. Finally, click on 'Use as featured image' to make your image part of the rolling slideshow on your home page. Press Publish>View Post once you're ready to launch the page.

Using a custom template

GraphPaperPress (see www.graphpaperpress. com) is a design company that has developed eye-catching Wordpress templates aimed at photographers and visual artists, but unlike most free Wordpress blogs, you have to pay for their templates that are written with Wordpress. Once you've downloaded the folder of files for your chosen template, unzip the contents and open the Instructions document. This will navigate you through the process of installing the files, either locally or on your web server.

REFLECTING ON YOUR SHOOT

Reviewing your work in progress is not just about picking the best shots – it can help confirm your approach and plan a follow-up shoot.

Making good creative work doesn't happen without proper review during developmental breaks. Taking stock of your progress is just as important as making the work. Print the images from your shoot, only deleting extreme errors, duplicates and mistakes. Never delete images that don't seem to fit in, especially those that appear random and disconnected from your main idea. These are often the most interesting and reveal the experimental, risk-taking side of your practice. Show your contact prints to others, especially more experienced photographers and tutors.

4.17

FEEDBACK FROM OTHERS

An essential part of developing your approach is to seek practical feedback from a more experienced photographer, tutor or even a peer. Working closely with your own project always prevents you from seeing the work as others do. Viewers of your project may pick up different interpretations, messages and meanings; this is a positive experience and should not be taken as negative criticism. If you seek advice and criticism during a portfolio review or group critical session at college, always ask a friend along as note taker, as it's difficult to write and concentrate at the same time. Your friend can note down research suggestions and advice on what to do next, while you engage with the feedback. When it's your friend's turn, you can reciprocate. With each feedback session, you'll develop a stronger sense of your own unique practice and be fortified enough to answer questions in the future.

PLANNING FOLLOW-UP SHOOTS

By putting yourself through a shoot/reflect/shoot workflow, you'll narrow down your idea into a more manageable, achievable output. Don't worry about scoring finished images too early on, finals will often emerge right at the very end of the process.

REFLECTION QUESTIONS

1 How did the images you planned beforehand turn out?

2 Describe the unexpected images. Why were you drawn to creating those?

3 Which images are the most difficult to categorize and why?

4 What message or meaning is emerging from the shoot?

5 How do you think others will read your work? How will they interpret it?

6 How has your project idea changed or developed during this shoot?

7 What's your next step?

4.17
Annotating your shoot is a good way to start editing down your work into a smaller, more coherent form. Emma Lavender's quick, reflective annotations enable her to pick up the project further down the line.

REVIEWING IN LIGHTROOM

Lightroom provides the best and easiest interface for reviewing your work and the simplest way of creating your own personal image archive.

4.18

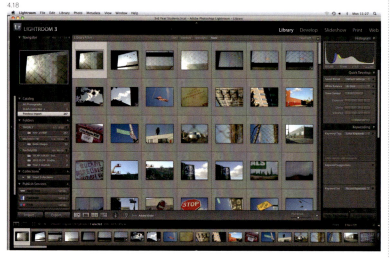

4.19

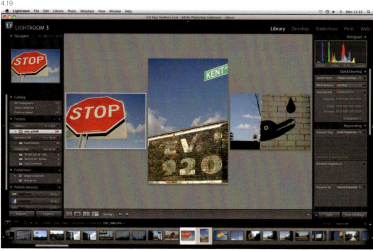

LOADING YOUR WORK

You can easily point Lightroom to any existing folder of images on your hard drive or import straight from your digital camera through a simple File>Import command. At this point, you also have the choice to copy or move your files into a new location. Best practice is to store all your files on an external hard drive inside a single 'Image' folder, creating a separate folder for each shoot containing the subject name and date, for example, newyork014 (see image 4.18).

ORGANIZING YOUR IMAGES

A significant benefit of Lightroom is the ability to arrange images into different groupings called Folders and Collections. If you've been physically arranging files and copies of files into different directories or folders in order to make an effective image archive, Lightroom provides a much simpler way to access your work. After import, each named shoot folder becomes permanently visible in the Folders panel on the left-hand side, so you can see the entire shoot with a single click. Eventually, all your shoots become accessible here after import, so retrieving your work becomes quick and stress free.

VIEWING FUNCTIONS

In the Library module, Lightroom presents you with a Grid view, where all your images are presented like a contact print, so you can visually edit your shoot with ease (see image 4.19). Poor shots can be deleted from the Library (but not your hard disk source), images can be rotated and even rated along a 1–5 star scale to help you tag favourable shots for later editing. In the Loupe view, you can zoom into a specific area of a single image to check fine focus and detail. Both Compare and Survey modes can be used for viewing two or more images in the central desktop panel, again useful if you want to compare slightly different variations in composition or exposure.

MAKING COLLECTIONS

Collections are another subcategory of organization in Lightroom, and are very useful for making early selections or groupings of images (see image 4.20). Collections are named folders that draw images from other shoot folders into a special compilation. Best of all, your files never move from their original location when incorporated into either of these two options, they are merely linked in rather than copied, and there is only ever one file. You can create a Collection for final project prints, first edit prints or perhaps to contain all the images for your portfolio. The contents of a Collection can always be changed.

4.20

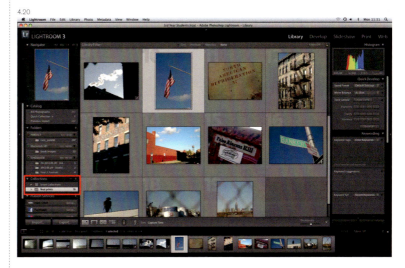

MAKING VIRTUAL COPIES

Occasionally, you may want to edit the same image in two different ways, perhaps comparing crops, colouring or retouching. Lightroom doesn't need you to duplicate files, but make virtual copies instead. Right click on any image and choose Create Virtual Copy. This now creates an alternative History for the chosen file, allowing you to plot a different editing path.

MAKING DIGITAL CONTACT PRINTS

It's bad practice to review each shoot on-screen, there's simply too much information to make a proper judgement; it's much better to make physical contact prints.

Contact prints are sheets of small images, or thumbnails, created after each shoot so that you can review your work in progress. Contacts help you to identify potential images for printing, and during the middle of a project can help you confirm a direction for your next shoot. Unlike contact prints made from photographic film negatives, reproduced at the same size and often only viewable with a loupe, thumbnails on a digital contact print can be any size you like and much easier to view.

Make your contacts on A3 paper, with five horizontal rows and five vertical columns – at this size, each image will reveal all its visual information for you to consider. If you print any smaller, you may not be able to judge sharp focus or you might miss a lurking detail. There's no need to print contacts on expensive inkjet paper, use the cheapest resin-coated media you can source.

MAKING A PDF WITH ADOBE BRIDGE

If you want a quick and easy way of making contact prints, the browser application Bridge provides the fastest solution. Equipped with an Output module, Bridge allows you to create a PDF document from a selection of images, which you can print or email to a client. Simply Shift+Click the images on the bottom filmstrip that you want to include in the print. Next, set the paper size, then Columns and Rows until it all fits together.

MAKING A CONTACT PRINT WITH LIGHTROOM

After choosing the paper size in the Page Setup box, the first step is to change the template to fit your precise needs. For this example, the 4x5 Contact Sheet template was chosen, then modified to a 5x5 by using the Page Grid controls. Finally, tweak the Cell Size modifiers making the gaps between each thumbnail small. Don't mix portrait and landscape images on the same sheet, as this creates wasted white space on your sheet and makes the thumbnails tiny.

4.21

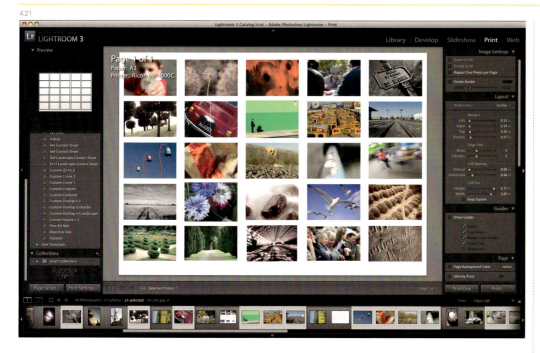

SELECTING THE IMAGES

The best way to start making a contact print in Lightroom is to Shift +Click each image that you want to include on the print. Once you have your final set of images all on a single contact page, sometimes they are not really in the right order (see image 4.21). To change the current position of an image simply deselect it by Cmd/Ctrl clicking its icon on the Filmstrip at the base of the application window, and notice it will temporarily disappear from your contact sheet. Next, click hold and drag this icon into a new place within the Filmstrip, dropping it into place. Notice that the first image on the far left of the Filmstrip is always placed in the top row, first column of your page. Once dropped into place, the image can be Cmd/Ctrl clicked again to bring it back into the contact print.

PRINTING TO FILE

Lightroom's contact prints can be printed directly from the application when completed, but you can also construct a JPEG file from your layout. This is useful if you want to send to a remote printing service, email to a client or simply print elsewhere. Once your contact print layout is complete, choose JPEG File from the Print menu in the Print Job section.

FIRST EDIT PRINTS

The first stage to developing your
final selection is to print off an early
set of images, but only those that
show potential.

4.22
Many photographers
hang up their images
before they make a final
selection for printing.

4.22

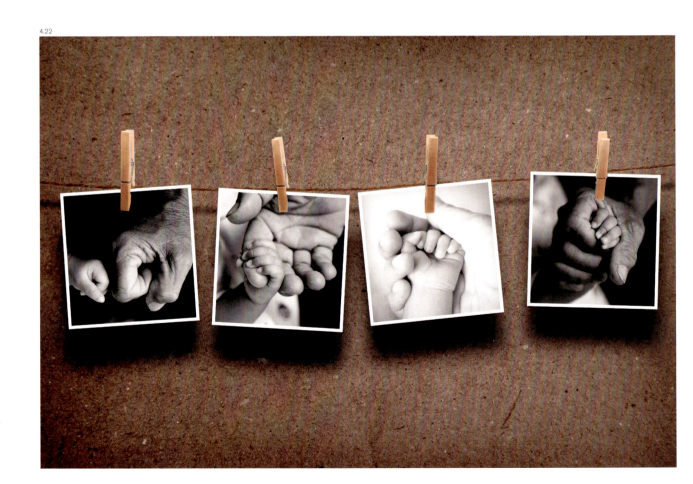

PRINTING AND VIEWING

First edit prints are made by all photographers in order to narrow down a large starting selection. With each shoot and subsequent printing, this selection will change and take shape into a more coherent set. To make first edit prints, it's not essential to fine-tune the print quality, but you must make the images big enough to be viewed on a wall, and with all fine details clearly visible.

Many photographers use a simple pinboard, washing line or shelf to help organize a growing number of first edit prints – and the last thing you should do is keep them hidden in a box. Viewing a larger set of proof prints constantly during the life of a project will enable you to reflect on the composition of the set as a whole and make value judgements about individual images. This kind of subtle decision-making rarely happens quickly, but over several days, as each photographer lives with their results in their own domestic space.

SEQUENCING

Many of the best-known projects are published as photo books and display a unique form of visual syntax in the sequencing of the images or their juxtaposition within the double-page spread. Yet this framing of the photographer's content originates not from a literary tradition, but from the complementary and rhythmic hanging of finished prints on a gallery wall to facilitate our physical meandering through its three-dimensional space. The sequencing plan of many photo books is devised by the editor or photographer by physically walking past proof prints laid out in a studio setting, re-ordering their running; rehearsing the reader's experience and refining their, as yet unmade, journey.

READING THE IMAGE

The link between photography and literature has been present from pictorialism onwards, when photographers' iconic images borrowed readily from established literary traditions using metaphor, connotation and symbolism to allude to their subjects. When reading your own work, decide on the function of your images: are they direct evidence, a construct or a symbol of an altogether bigger issue?

READING THE SERIES

Our encounter with a group of images has a greater connection with reading, and received literary genres, than any visual art experience. So the sequential deployment of images in a display, exhibition or photo book delivers a more complex message than any individual, indexical print can indeed manage. Reading a sequence of images is an unpredictable experience, more similar to the cumulative resonance of a film's montage sequence, so it's important to think how your project might accrue its message as a whole, rather than as a series of shorter, unconnected statements.

4.24

ASSIGNMENT: REFLECTIONS ON THE ARCHIVE

4.23
Katie Treadwell's first edit selection shows a halfway stage between contact sheets and final print.

4.24
This image is from Martin Parr's book *The Last Resort 1985*, which chronicles the holiday resort of New Brighton, UK. Parr was one of the first photographer's to use colour photography in documentary works. Explore his work further.

In this assignment you will act as a curator and should treat sensitively and respectfully the work of others.

THE BRIEF
Research and visit a specialist online image archive or museum. Create a photo book containing images that you have gleaned from your search, identifying work that links to your own interests and critically reflecting on the legacy it has left, especially if it has a resonance with current events.

As you collect and refine your selection, remember that in this exercise you are working as a curator – repackaging and representing the work of others. Each editing decision you make will have a profound effect on how others read and interpret the work.

You must produce the following:

1 A spiral-bound or perfect-bound photo book, containing a 250-word introduction identifying the value of the work you have unearthed.
2 A separate written reflective evaluation describing what you have learned during the project.

4.23

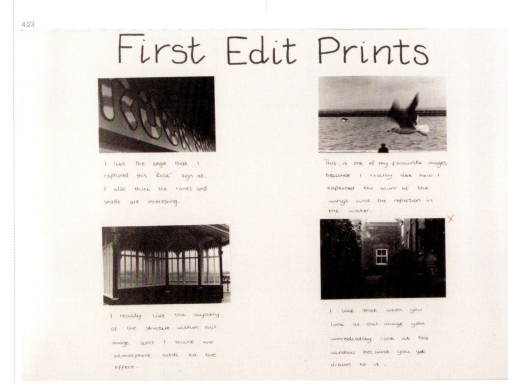

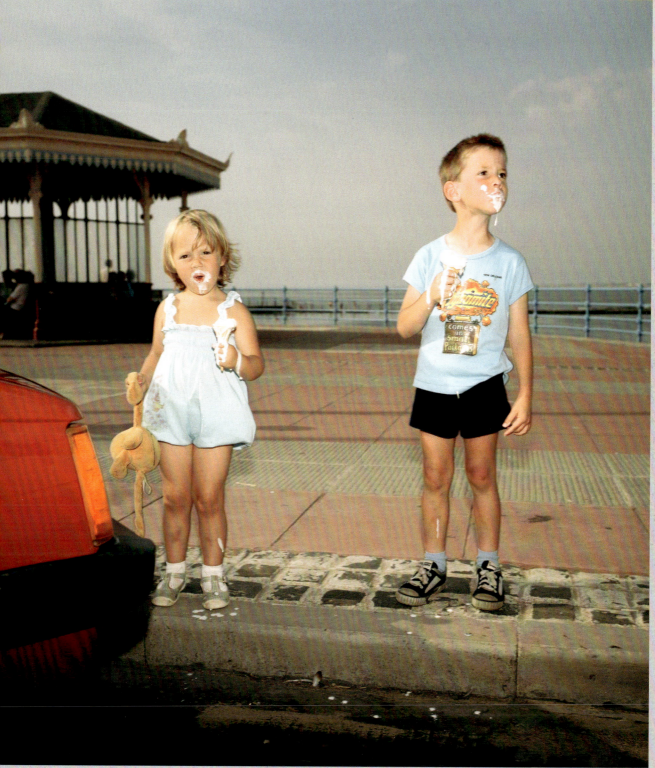

CHAPTER 5

TREATMENT

Despite the endless benefits of shooting with a digital workflow, there's simply no substitute for craft. All great photographers have an innate understanding of their chosen materials and equipment, deploying it in such a way as to create a unique 'look' or visual style. Digital editing overlaps many of the traditional stages of photography, blurring the different processing, enhancing and printing stages, making it difficult to know when and what the end point should be. This chapter takes you through the critical stages of editing and shows you how to squeeze every bit of quality out of your file. The golden rule with digital editing is to make as few steps as possible and keep your commands reversible. Less is more.

'All the technique in the world doesn't compensate for the inability to notice.'
Elliott Erwitt

NON-DESTRUCTIVE EDITING

The best way to use software is with restraint; the fewer editing steps you make, the better quality print you will create.

PRINCIPLES OF NON-DESTRUCTIVE EDITING

In simple terms, non-destructive editing describes how an image is protected during editing and not overwritten with each command. When an image is first opened, an image editor, such as Photoshop, converts the complex strings of pixel data into colours, shapes and lines. If the original file is never modified or re-saved, this original data is left intact. However, after many edits, delicate colour and tone will deteriorate as the cumulative effect of editing stacks up. With non-destructive techniques, quality is maintained as far as possible; you can return and reprocess at any stage in the future. In hindsight, it's simple to see the results of over-processing an image file, but it's often invisible while you are working.

WORKING NON-DESTRUCTIVELY IN PHOTOSHOP

It's possible to work non-destructively in Photoshop, but you have to plot your work in a very specific way. By using Adjustment layers, Smart Objects and Smart Filters, or retouching to a separate or duplicate layer, or using Masks, you protect the original pixel values while you render your work from file to print (see image 5.1).

PHOTOSHOP'S ADJUSTMENT LAYERS

Most of Photoshop's critical commands, as found under the Image>Adjustment menu are also available as Adjustment layers and can be introduced to your image with ease (see image 5.2). Levels, Curves and Color Balance commands can all be applied to your image and appear in their familiar dialog box state once actioned. Once applied to the image, the Adjustment layer appears in your layers' palette with the name of the command. After making an edit and quitting the adjustment layer, you can simply return to the command at any time in the future and pick up where you left off.

5.1

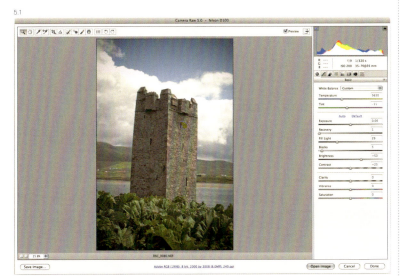

5.2

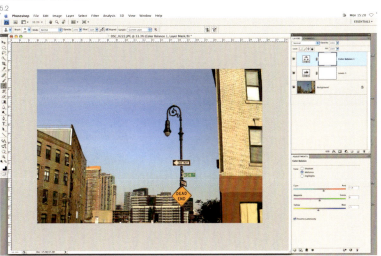

CHANGING YOUR MIND

The state of the dialog box is saved every time, so you're never in danger of over-editing your image if you decide to change your command at a later stage. Sliders, curves, and numerical text boxes remain unchanged with your last set of commands and give you flexibility and choice. Lying in the stacking order like normal layers, Adjustment layers apply themselves to the layers sitting underneath, but Layers above remain unaffected.

NON-DESTRUCTIVE SOFTWARE

If you are shooting RAW files and use Lightroom, Aperture or Adobe Camera Raw as your sole image editor, then you are already using a non-destructive workflow. All these applications 'float' commands in a permanent state of flux over your image, so you can return and rejig without overcooking your work. However, if you use the menu-driven commands in Adobe Photoshop and Photoshop Elements, then every single edit applied through a dialog box or menu, followed by a save command, will permanently overwrite and distort the values of your original pixel colours.

148

OTHER NON-DESTRUCTIVE WORKFLOWS

There are many other applications that can be used to edit your images and some that can be combined together for even greater quality control.

USING PHOTOSHOP AND THE ADOBE CAMERA RAW (ACR) PLUG-IN TOGETHER

The ACR plug-in is a freely available piece of software issued with all versions of Photoshop and Photoshop Elements. The plug-in is also regularly updated. You can use this workflow for processing RAW files first in Camera Raw, then add creative effects using Photoshop. This workflow maintains a non-destructive environment in two applications simultaneously, and also allows you to move back and forth.

In a straight RAW workflow, files are first technically processed in Camera Raw to set white balance, contrast and colour, before creative enhancements are applied in Photoshop. At the point of exporting into Photoshop, the link between Camera Raw is normally broken – you can't export the file back from Photoshop to Camera Raw without losing your creative work. You can get around this by using Open Object command while your RAW file is still in Camera Raw, then place it in Photoshop ready for editing. To return, click the tiny Smart Object layer icon in Photoshop and watch the RAW file ping back into the Camera Raw dialog for further architectural alterations, which are then reflected in your Photoshop file.

5.3

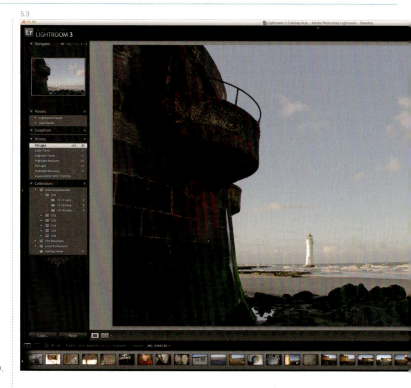

THE AUTO-ADJUSTMENT DILEMMA

By default, the Adobe Camera Raw plug-in applies a stack of preset edits to your file under the guise of Auto Adjustment. If you'd rather create your own personal adjustments, you must first turn off this function. Found within a pop-up menu to the top right of the Settings panel, you can deselect the Use Auto-Adjustments option. Once switched off, you are then presented with an accurate preview of the RAW file, darker than you'd expected and with a histogram shape that looks like the file was underexposed.

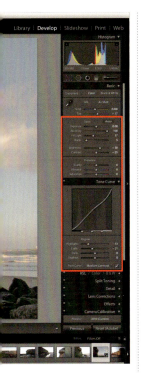

ADOBE LIGHTROOM

Unlike the Adobe Camera Raw and Photoshop partnership, the unique design of Lightroom allows you to work on RAW files without the need for an intermediate processing stage (see image 5.3). Not only that, but the application allows you to see and edit a large number of files simultaneously and keeps all your editing choices in a state of permanent flux in a separate Library file. So, you never have to press Save or worry about over-editing your image, as the application's History keeps a permanent record, allowing you to backtrack even on images that you'd worked on weeks ago.

USING CAMERA PROFILES IN LIGHTROOM AND ACR

A colour-managed environment is the best way to ensure quality prints by using a carefully calibrated monitor, synchronized colour space and printer profiles. You can also fine-tune your workflow by creating a bespoke profile for your camera and lens combination, without the need for expensive profiling gadgets or complicated software.

When editing RAW files in the Adobe Camera Raw plug-in or Lightroom, most users are unaware of the background processing of RAW files that takes place. When the editor recognizes the camera model that created the file, a generic set of adjustments kicks in and applies a predetermined recipe to your image, whether you want it or not. You can improve this by ensuring you have downloaded the latest update to ACR or Lightroom, as this will contain profiles for all the latest camera models.

5.4

Different camera profiles 'mix' original colour from your RAW file into a different end result.

5.4

5.5
Properly edited images
display a full dynamic range
from a deep black shadow
to pure white highlight,
as this example shows.

CORE IMAGE EDITING

To simplify your workflow, it's a good
idea to follow the same editing sequence
for enhancing each of your chosen
images. There are five steps to help you
digitally edit your images in the areas of:
contrast and brightness; colour balance;
retouching; saturation and sharpening
and creating localized emphasis.

5.5

STEP 1: CONTRAST AND BRIGHTNESS

To create a professional result, it's essential
to set contrast and brightness first. In a digital
image, colour is created by mixing three
separate colour component channels: red,
green and blue (RGB). Within these channels,
brightness is placed within a 0–255 scale
where zero is black and 255 is the colour at its
maximum saturation. When editing, we view
an amalgam of all three colour channels and
changes to pixel brightness can be made very
simply. Many images lack proper contrast due
to dull location lighting; any slight exposure
errors will need fixing too. Most amateur
images are never edited properly and lack
a pure white and a deep black. It's impossible
to edit colour correctly before setting contrast
and brightness first, so this is always the first
edit to make.

Editing with Levels

The Levels dialog box, found under
Image>Adjustments, is the best tool for
adjusting both contrast and brightness of your
images. Levels display contrast and brightness
information in a kind of graph called a
'histogram'. Once you've really got to grips
with the histogram, you can carefully process
and prepare images to create perfect prints.

Understanding the histogram

The histogram graph, found in the Levels
dialog, shows the spread of pixels across
this scale together with their quantity
in each tonal area. All digital images are
different and therefore the levels histogram
will be a different shape for each image.
However, for common photo mistakes, such
as underexposure and overexposure, or high
contrast and low contrast, the histogram
shape becomes recognizable.

5.6

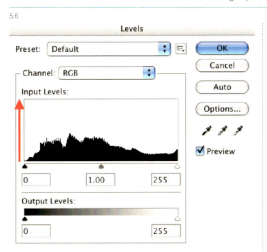

5.8

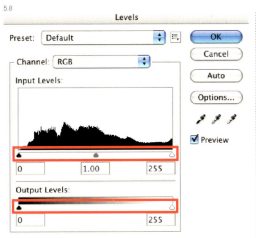

5.7

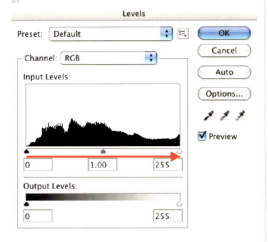

Pixel brightness scale

Arranged along the base of the histogram's horizontal axis is the 'pixel brightness scale' (see image 5.7). At far right is the white point, at the far left is the black point, and neutral grey is found in the centre. In an RGB image, Levels editing is best done on the composite RGB channel.

White, black and grey points

In image 5.8 two scales are present in the dialog – the Input scale for adjusting brightness and increasing contrast, and the Output scale for reducing contrast. At the base of the histogram are three movable triangular Input sliders, white at far right, grey in the centre and black at far left. The Output scale has only two sliders: white and black.

Pixel quantity scale

Arranged along the left-hand side of the histogram's vertical axis is the 'pixel quantity scale' (see image 5.6). At the base of the scale is zero – denoting no pixels; the top of the scale denotes many. Quantities displayed do not indicate a high- or low-resolution image, but are proportional to overall pixel count.

5.9a

5.9b

MAKING DARK IMAGES LIGHTER

Open your Levels dialog and work on the Input sliders found at the base of the histogram shape. Drag the central grey midtone slider to the left until your image becomes brighter. This will not change your highlight and shadow points.

MAKING LIGHTER IMAGES DARKER

When faced with images that are lighter than you want them to be, use the Input sliders to make your corrections. Drag the central grey midtone slider to the right until your image becomes darker and loses it's washed out look. Avoid going too far or your printouts will look dark and heavy (see images 5.9a and 5.9b).

5.10

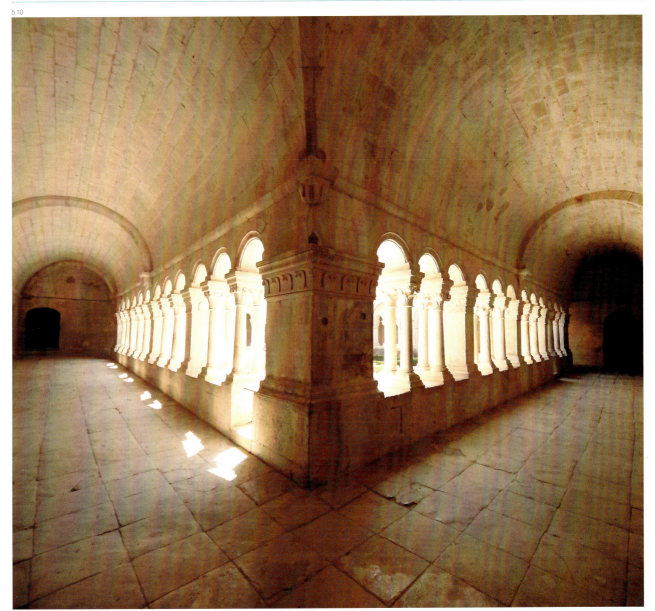

5.10
Careful image editing
permits the actual
lighting atmosphere to
be conveyed in the final
print or screen display,
as this example shows.

5.11

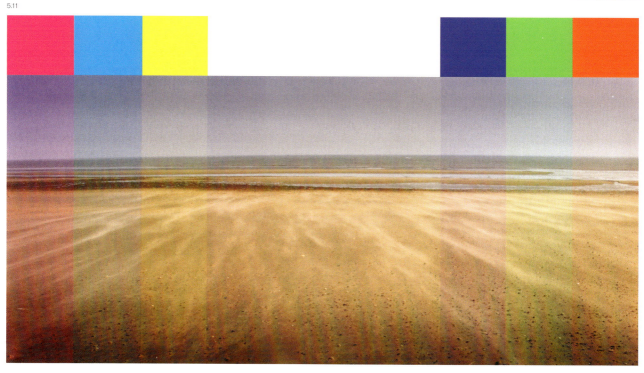

5.11

The best place to observe colour casts in your photographs is in a neutral colour area, preferably grey. Strong white highlights and deep black shadows will never display a cast, nor will a patch of fully saturated colour, but if you are lucky to have a midtone grey in your image, you'll get a much better idea about the extent of your problem. If no such grey is present, use a skin tone area to base your corrections on.

STEP 2: COLOUR BALANCE

Even the best photographers end up with colour casts in their image, these are subtle transparent washes of colour that make the print look flat and uninspiring.

Faithful colour reproduction is a never-ending pursuit for professional photographers and printers, a process made more complex by the many cameras, scanners and printers working with completely different standards. Colour casts make an image look dull and muddy and prevent the bright colours you'd expected from singing at the tops of their voices. Yet casts are easily removed as long as you know the fundamental principles of the colour wheel.

5.12

5.12

In all colour reproduction, there are six colours broken into three pairings: red and cyan, magenta and green, blue and yellow. When colour casts appear, they are caused by an exaggerated amount of one of these six colours. Casts are simply removed by increasing the amount of the opposite colour until it disappears.

Casts created on location

The colour of natural daylight is far from consistent and varies depending on location and time of day. Photographs taken in the early morning can appear bluer and 'colder' than the same subject shot under a midday sun. Towards the end of the day, natural light becomes redder and produces warmer and more inviting results. The location can also have a dramatic effect on colour reproduction; even an innocuous canopy of trees can cast a deathly green colour across any portrait sitter unlucky enough to sit underneath.

Casts created by artificial lighting

The colour of light produced by an artificial light source is not drawn from an even spread of the spectrum like natural light. Instead, this kind of light is produced in a narrow range, such as green or orange. Domestic light bulbs are usually based on a tungsten filament and produce deep red orange results. In contrast, fluorescent tubes produce a heavy green cast, which sucks the life out of any colour photograph. Although the White Balance settings on your DSLR can combat this, problems occur when you mix daylight and artificial light in the same shot.

Option 1: Warming up or cooling down in ACR or Lightroom

RAW files are easy to colour correct by adjusting the White Balance settings via the Temperature control in Adobe Camera Raw and the Temp slider in Lightroom. To make your image warmer, move the slider to the right; to cool down move to the left (see image 5.13).

5.13

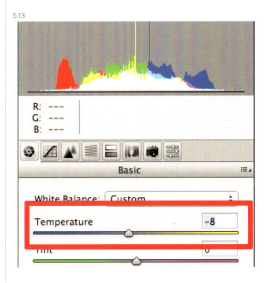

OPTION 2: WARMING UP OR COOLING DOWN USING PHOTOSHOP'S COLOR BALANCE CONTROLS

More advanced control can be achieved using the less user-friendly colour balance sliders in Photoshop. To warm up add +3 yellow and +3 red; to cool down subtract -3 blue. Always edit in the midtone sector (see image 5.14).

5.14

5.15

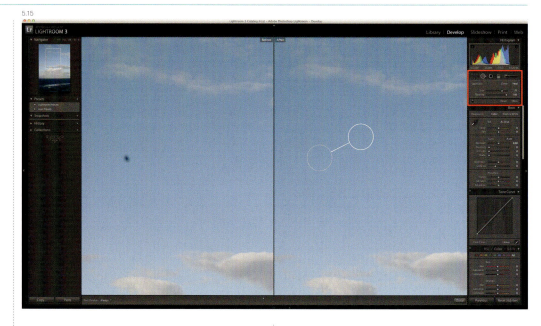

Retouching can potentially destroy your original image, so it's best to separate off your Clone Stamp work in another Layer – just in case! Do Layer>New Layer, then select the Clone Stamp tool, set with Sample All Layers. Set the Brush size so it's bigger than the mark you want to paint out, then set the Brush Hardness to 0%.

STEP 3: RETOUCHING

If your photographs are ruined by the appearance of unwanted items, you can easily paint them out without causing permanent damage to your RAW file.

The Clone Stamp tool

Common to both Photoshop and Lightroom, retouching tools offer a great way of exploring the magic of digital photography. Retouching works by sampling or copying a smaller part of your image then pasting it over another, unwanted area. Unlike any other painting tool in the Photoshop toolbox, the Clone Stamp tool has no connection with any real-world painting technique and will feel like painting with a brush loaded with 'image' rather than colour. The real skill of the tool lies not in its application, but in the selection of the starting sample area. The tool is perfect for removing dark spots caused by dust on the image sensor and hair acquired from flatbed and film scans. Like all other painting and drawing tools in the box, the Clone Stamp can be modified by brush size, shape and opacity and also by its blending mode, although most useful work is carried in the default Normal blending mode.

Starting to retouch

On the top menu bar, choose Aligned mode as this lets you continue retouching in a different part of the image, but fixes the distance from sample area to painting area. This means you need to have two sets of eyes to watch what you're copying and where you're pasting it. If the sample point isn't changed regularly, a repeat 'herringbone' pattern will appear. With your non-mouse hand placed over the Alt key, move the Clone Tool onto an area of the image you'd like to sample. Next, press and hold the Alt key and click once with your mouse. Notice the tool icon changing as you make the sample. Move the tool cursor away from the sample point and position it over the area you'd like to remove. As you start painting, a tiny crosshair will appear to tell you which part of the image you are sampling from.

Retouching in Lightroom

Although Lightroom appears to be processing the RAW file directly, it's actually 'floating' edits in limbo, only embedding your commands when a file is finally exported. Lightroom's equivalent to Photoshop's Clone Stamp, the Spot Edit tool, is easy to use, but works in the opposite way – you click on the problem first then drag the brush, which feels like it's on the end of an elastic band, into an area that you'd like to clone. The cloning takes place in real time, so you can see the result immediately and each time you move the brush cursor. Once the Spot Edit is complete, press Close. Unlike Photoshop, each Spot Edit remains editable at all times in the future, so you can easily rejig your effort by simply clicking on the thin white circle to reactivate it.

5.16

While retouching is used to correct images it is also used to create special effects. This image has been retouched to give it a surreal quality.

5.16

5.17a–5.17b

In this example, dull reds as captured in the original file have been intensified with a simple, single command.

5.17a

5.17b

5.18–5.19

Every image benefits from a slight increase in saturation values, best applied using the Hue/Saturation dialog as an Adjustment Layer. Once opened, use the Master channel in the drop-down menu to intensify all colours in the image, or target individual colours with your edit. This example used a small edit of +15 to make a significant difference.

5.18

5.19

STEP 4: SATURATION AND SHARPNESS

DSLRs are purposely designed to create slightly soft and flat images, so you need to redress these issues in your edit.

What is saturation?

Saturation describes the intensity of a colour and this can easily be put back into an image, or made even more vivid than it was in the original scene. A small increase in colour saturation can make a much more attractive print; redress these issues in your edit.

What is sharpening?

Sharpening is nothing more than increasing the level of contrast between adjacent pixels sitting on the edge of a shape in an image. In a blurry subject, such as a cloud, colours are muted at the edges of shapes. In a detailed, pin-sharp image, colours are much more widespread and have inherently more contrast, particularly at the boundary edges of shapes. All digital camera images are captured with a slight soft-focus effect due to a hidden anti-alias filter fixed in front of the sensor to prevent the destructive effects of jaggy staircasing. Despite the presence of in-camera sharpening settings and sharpening filters on film and flatbed scanners, it's much better to shoot without sharpening turned off, as you can never remove the effects of a crude filter later on.

5.20

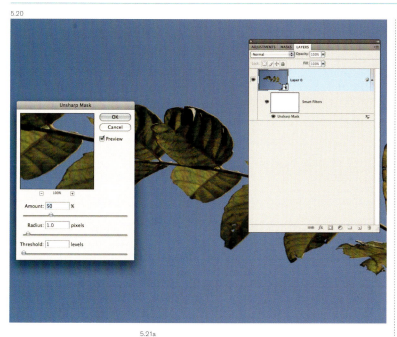

The Unsharp Mask filter

The most sophisticated way of sharpening is to use Photoshop's Unsharp Mask (USM) filter (see image 5.20). Found under the Filter>Sharpen>Unsharp Mask command, the USM has three controls: Amount, Radius and Threshold.

Amount describes the extent of the change of pixel colour contrast with high values suitable for more out-of-focus images.

The Radius slider is used to determine the number of pixels surrounding an edge pixel, with low values defining a narrow band and high values creating a thicker edge. Radius is best slid slowly towards the high end until edges are sharp, but not in relief.

The final Threshold modifier is used to determine how different a pixel is from its neighbours, before sharpening is applied. At a zero threshold, all pixels in an image are sharpened equally, resulting in a noisy and unsatisfactory result. Set at a higher value, less visible defects will occur overall. The most flexible way of applying the USM is as a Smart filter, permanently editable and floating over your image, either edge to edge or through a mask. A good starting point for most images is Amount: 50, Radius: 1 and Threshold: 1.

5.21a–5.21b

All images can be improved by software sharpening, but it's important to apply it in the correct manner, or it can easily destroy fine quality. In this example, notice the difference between a sharpened and unsharpened version of the same image.

5.21a

5.21b

5.22a–5.22b

In this example of a mask, the white part of the mask is the 'hole' and the surrounding black area protects the underlying image from the edit.

5.22a

5.22b

WHAT ARE MASKS?

Masks are the best way of maintaining flexibility when you want to work on smaller parts of your image. Masks are interleaved between different Layers, providing a stencil-like barrier between the edit and the image. Best of all, the perimeter shape of the stencil-like hole in the Mask can be changed constantly, so it can be made to fit exactly the area to be edited.

In a non-destructive workflow, Masks are best applied alongside Adjustment Layers or Smart Filters, allowing you to fine-tune both the extent of the edit and the territory it covers. Masks can be saved and stored in the Photoshop .psd file format, so you can return and refine at any time in the future.

Linking a Mask with an Adjustment

To link a Mask with an Adjustment Layer, use any of Photoshop's Selection tools to encircle a specific area of the image, which can then be used to create a Mask. Once the selection has been created, apply the Adjustment Layer and notice how an additional black-and-white icon will appear in your Layers Palette.

MASKING IN LIGHTROOM

While Lightroom doesn't have Layers to separate out smaller areas of the image, it does have the Adjustment Brush, which is a combined Mask and Adjustment layer tool. The Brush is used to paint an edit into the image, but the extent of the edit is always flexible, and the area it's applied to can be altered, too. Each use of the Adjustment Brush is indicated by a tiny button within the image itself, as shown, which can be used to activate it at a later stage for fine-tuning.

Reshaping the Mask

To reshape the Mask, click on the Mask icon and select White and Black as the foreground/background colours, then pick the Brush tool (see image 5.23). Set the Brush with a 100-pixel size and 0% Hardness. With White as the foreground colour, the Brush cuts holes into the Mask allowing the edit to affect more of the underlying image. When the foreground colour is changed to Black, these 'holes' can be filled in. The advantage of using a Mask is that the image layer remains intact while the Mask can be cut and repaired as many times as you like.

Photoshop's Quick Mask

Photoshop's Quick Mask editing mode is an easy way to start making selections, especially if you prefer to 'paint' a selection area rather than struggle with selection tools (see images 5.24a and 5.24b). Quick Mask mode creates a temporary red stain over the areas you've marked up for selection, which you can keep adding to. Once the Mask is complete, toggle back to Normal edit mode to see the selection shape you have created. You can do this as many times as you like.

5.23

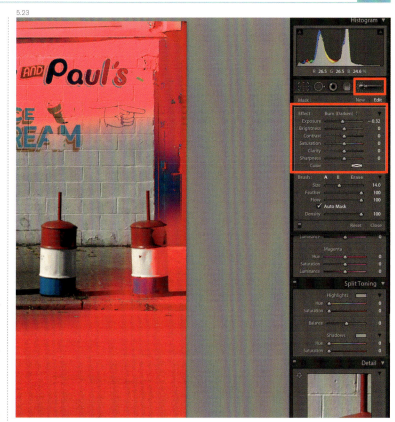

5.24a

5.24b

STEP 5: CREATING LOCALIZED EMPHASIS

Derived from the skills of the traditional darkroom printer, digital burning-in and dodging helps to emphasize the main subjects in your image.

The best photographic prints undergo an extra editing stage when individual areas of the print are darkened down or lightened up to create a much more sophisticated result. Both natural and artificial light never fully models each individual part of an image, so burning and dodging can help make an image look more three dimensional and more inviting to look at.

Step A: Define the burning-in area

Rather than use Photoshop's brush-shaped burning tools, a better method is to use the Lasso selection tool. Check that the Feather value is set to zero on the contextual menu bar before you start, then resize the view of your image using the Navigator tool, so there is plenty of grey desktop space surrounding the image edges.

Next, draw a simple enclosed selection shape (see image 5.25a), in an area of the image that you want to darken, placing the Lasso in the grey desktop areas as you draw around the edges to ensure you capture the peripheral pixels. This selection now becomes the area that you will add extra 'exposure' to, but first must be softened before the next step using the Select>Modify>Feather command. Set this value to 5% of the maximum pixel dimensions of your image, for example, 2000 divided by 5% is 100 pixels.

Step B: Making an Adjustment layer

Next, do Image>Adjustments>Levels and drag your dialog box to one side, so you can see the entire image. To darken down the selected area, move the grey midtone triangle to the right (see image 5.25b), but avoid trying to complete the effect in a single command. The area will now have turned darker, but with a soft edge that mimics the kind of gradual change created by darkroom hand-printing.

5.25a

5.25b

USING LIGHTROOM

The same effects can be made using Lightroom's Adjustment Brush.

5.26a

5.26b

Step C: Repeat in a smaller area

After the first effort, repeat the command again, but this time in a scaled-down selection area. Like burning in a conventional photographic print with a third period of 'exposure', this stage enables you to further darken the area. Using the Lasso tool again, make an irregularly shaped selection that sits inside your first attempt, but avoid being too perfect, or your dark shapes will start to look obvious. Shown here are the before (image 5.26a) and after (image 5.26b) states compiled into a single screenshot. The most convincing example of this technique can be produced when several differently shaped increases in print 'exposure' are built up in a single area, rather than in one direct hit.

Final print

The finished example was the result of many selections and burning-in using the Levels midtone slider (see image 5.27). By using this part of the Levels tool, only the midtones are altered each time you create a burning-in effect, minimizing the risk of making burnt-out highlights or blocked-up shadows. With so many small and overlapping selection shapes, it's impossible to see where the editing has taken place.

5.27

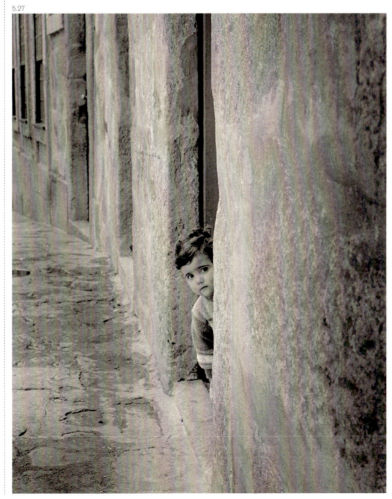

MONOCHROME CONVERSION

Sometimes, bland or insipid images can be made visually stronger by converting to black and white.

5.28

COLOUR AND TONAL REPRODUCTION

In digital photography, the universal three-channel RGB image enables us to remix the original balance of an image's entire colour palette and tonal relationships. What's even better is that the conversion techniques can be reapplied retrospectively to any digitized colour image from your library, even if it was shot on ancient film stock (see images 5.28 and 5.29a–5.29b). When making a conversion, pixel colour is remapped to another value, but the key to doing this properly is to avoid destroying smooth tonal transitions with excessive editing.

Using Adobe Camera Raw

Similar controls can be found within Adobe Camera Raw under the HSL/Grayscale tab. Although each original colour within your project image can be altered to create a lighter or darker tone, the final result is created as a grayscale file rather than an RGB. This is less versatile, as you can't add any colour tint or tone (or any colour for that matter) to a grayscale file later on in your editing sequence.

5.29a

5.29b

5.30
Any colour present in your original image can be lightened or darkened during the process of monochrome conversion to generate a more interesting result. Colours that are too similar in the RGB image can be made to stand apart, like the blue sky and clouds in this example.

5.30

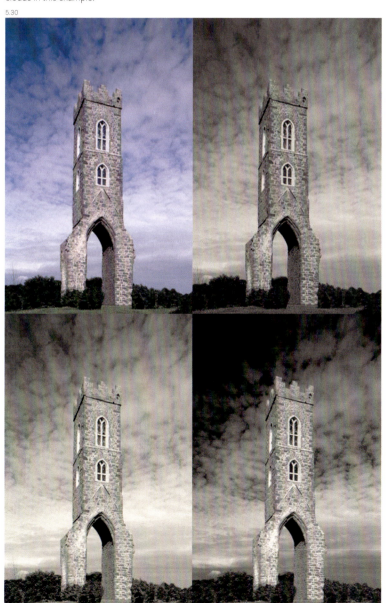

NOISE AVOIDANCE

Like many software enhancement techniques, converting to black and white can be fraught with danger. Although most of the tools and processes offer a dazzling and seemingly unlimited scope, if used in excess, they will introduce the biggest of all gremlins into your image – noise. Lowest quality and noisiest results will be created if you edit highly compressed JPEG files shot at a high ISO (800+). Before any editing takes place, this kind of file will be full of compression artefacts and grain-like noise, which will magnify throughout a very shortened editing process. Be cautious, just because software allows you to make an extreme edit, there's every chance your result will be low quality.

USING PHOTOSHOP'S BLACK-AND-WHITE FILTER

The best way to make a monochrome conversion in Photoshop is to use a Black-and-White Adjustment layer to draw out the difference between tones in your original. The on-image adjustment tool allows you to grab hold of the tone you want to change in your image. Click onto the area, then move left to darken or right to lighten. You can also simply move each of the colour sliders left and right to see what effect is created and underneath the pop-up Preset menu, there's a selection of traditional filter 'recipes' which you can try, too.

5.31a–5.33

Many colour images have little or no noticeable colour in them. Converted to monochrome, the shot looks more visually interesting.

MONOCHROME TREATMENTS

Toning describes the addition of one of more transparent coloured tints to a monochrome image, typically to enhance the illusion of three-dimensional space.

TONING ESSENTIALS

Traditional photographic print toning required chemical agents, such as sepia and selenium, to make prints with limited colours ranging from brown to purple-reds. With the digital process, however, there are many more colour options available. Digital colouring in both Photoshop and Lightroom means you have control over the toning process, adding colour across the whole image, or dropping it into different tonal sectors. The trick with toning is to apply just enough colour to create the illusion of three-dimensional space. Add too much colour and your print will look heavy and overcooked.

USING PHOTOSHOP'S COLOR BALANCE CONTROLS

Begin with an RGB image that has been 'drained' of its colour by doing Image>Adjust>Desaturate.

Step 1: Toning the midtones

Go to Image>Adjustments>Colour Balance. Here, you are faced with familiar Cyan to Red, Magenta to Green and Yellow to Blue opposites. Move any sliders until you achieve the desired tone effect, but keep the Midtones and Preserve Luminosity buttons checked. This example had -19 magenta and +26 yellow applied to the midtones (see images 5.31a and 5.31b).

5.31a

5.31b

5.34

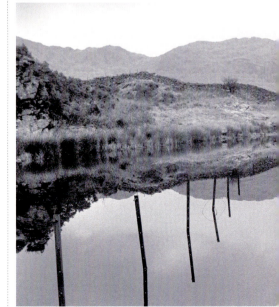

Step 2: Toning the highlights

Next, apply a different colour to the highlight by checking its respective button, then moving the sliders making a more subtle mix. To create a colour in the highlights, this example had an extra +22 yellow applied. Avoid saturated colours and be careful about making the image too heavy, as shadows can clog up during printing (see images 5.32a and 5.32b).

Step 3: The result

By applying yellow to the highlights, this print took on the appearance of a split-toned chemical darkroom print (see image 5.33).

5.32a

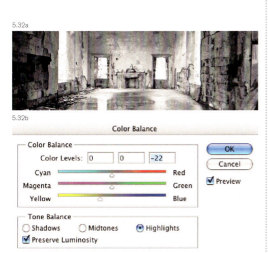

5.32b

5.33

Split toning

The same effect can be created using Lightroom's Split Toning panel. Unlike Photoshop, Lightroom provides an additional Balance control that allows you greater flexibility to 'mix' the relationship between highlights and shadow colours.

5.34

The same technique can be used with other colour palettes, such as two strengths of blue, as shown here.

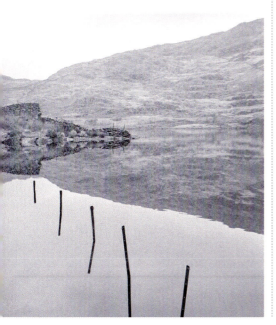

ASSIGNMENT: NARRATING THE WORKFLOW

Refining your software skills is an essential part of developing a professional attitude to post-production. Software technique can be tricky to remember, especially if you don't practise regularly.

THE BRIEF

For this assignment, create a video tutorial demonstrating how to do one of the techniques you have learned in this chapter. Pick a simple sequence that lasts under five minutes and create a voice-over to accompany it.

If you are an Apple Mac user, you can record your screen activity using QuickTime's screen recording function, then package your movie file for your school or college's virtual learning environment using iMovie. Windows PC users can record screen movies with Camtasia Studio or the equivalent.

You must produce the following:

1 A finished five-minute movie file demonstrating a technique, suitable for a beginner.
2 A separate written evaluation describing what you have learned during the project.

5.35
Oli Kellet's prizewinning image uses a simple blend of two or more studio images to create an amusing but slightly unsettling effect.

5.35

CHAPTER 6

OUTPUT AND FINISHING

The shock of the new desktop printing revolution seemed to herald the end of darkroom craft skills to many analogue photographers. Yet nothing could be further from the truth – today's digital photographers enjoy more ways of distributing their ideas than ever before. Through a throwaway posting on a social network, to a finely tuned digital C-type on a gallery wall, or a carefully designed photo book, your work can be packaged in many ways. This chapter takes you through the fundamentals of image output for paper, screen and printed matter. Choosing the right medium to encapsulate your project is not straightforward, so you should experiment with a wide range of different materials and services.

'We're at a tipping point. The digital print is becoming the look of our time, and it makes the C-type print start to look like a tintype.'
Joel Sternfeld

PACKAGING FOR INKJET

Despite the immediacy of inkjet printing, it's important to work in a methodical way to ensure consistent results.

6.1

Better inkjet printers use different coloured ink – the more the better. Professional inkjets use orange and green inks to better mimic flesh tone.

6.2

The most important controls for printing at top quality are found within your printer software. After choosing the Print command, make sure you pick the closest match to your print media from the Media drop-down menu, as this will have a huge influence on print quality. Next, set your print quality to its highest available option, sometimes referred to as High, Photo or 2880dpi.

6.3

Inkjets create the illusion of a photoreal print by dithering – a process of breaking up your pixel-based image into tiny ink droplets.

6.1

6.2

6.3

CHARACTERISTICS OF AN INKJET PRINTER

Just like lithographic printing of photographs in magazines and books, an inkjet printer uses the same four ink colours: cyan, magenta, yellow and black. The resulting print is created by millions of tiny drops of colour and when viewed from a distance these merge to give the impression of continuous photographic tone. The best inkjet printers are those with extra colours such as vivid magenta, green and orange and three different strengths of black. High-resolution printers create ink droplets at different sizes to make a more photorealistic effect; these are expressed in dots per inch (dpi), such as 2880 or 1440dpi. The bigger this number, the finer and more photorealistic your prints will look.

IMAGE RESOLUTION FOR INKJET PRINTING

The resolution of most inkjet printers is somewhere between 200–240 droplets per inch and there is very little visible difference in print quality between these two values.

PRINTER DRIVER SETTINGS

Printer driver software can be the biggest barrier to making a good print. Printer software converts pixel colour into ink, using preset recipes combining printer resolution, media type and colour balance. The combination of these settings can trigger a sequence of unwanted adjustments on your print and can negate all your hard-won editing.

TEST PRINTING

When you've worked out the best printer software settings for your paper, there's still no guarantee of a perfect print. Test printing helps you to solve simple problems quickly and make better use of costly ink and paper consumables.

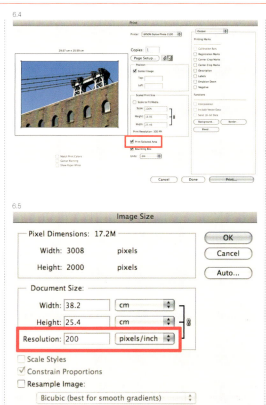

6.4

6.5

6.4

In Photoshop, pick the Rectangular Marquee tool and make a selection of an area of your image containing both highlights and shadows. In the Print dialog, switch on Print Selected Area, as shown. Cut a small piece of your chosen paper and print out several different variations to compare.

6.5

In Photoshop, open the Image Size dialog and first uncheck the Resample option. Next, change the Resolution to 200 pixels per inch; this will set the maximum print size available as shown in the Document size readouts.

6.6a

6.6b

6.6c

6.6a–6.6c

Wait five minutes for your prints to dry, and then view under daylight conditions. Monochrome or toned images frequently print darker than expected due to the way RGB image colours are translated into printer ink colour. Shadow areas can also start to fill-in and prevent image detail from appearing. Colour prints also become much less vivid when dark. To correct your image, cancel the selection, and then return to your Levels midtone slider controls to lighten or darken. Using Paper profiles in your workflow creates better results with less test printing.

6.7a–6.7b

Gloss paper shown in image 6.7a better reproduces saturated colour compared to matt or lustre surfaces as shown in image 6.7b.

6.8

Helping to keep the paper rigid and improve the brightness of the image overlay, the use of Baryta makes an exciting link between this new material and old darkroom favourites. Some papers have an off-white or cream base colour and can be very effective for monochrome or toned prints.

PAPER CHOICES

If you decide against using glossy inkjet paper, you can add a further personal dimension to your individual photographic practice by trying brands that are more exclusive.

PAPER ESSENTIALS

Inkjet paper made by recognized brands, such as Epson, Harman, Hannemuhle, Canson and Moab, give better, longer lasting results than cheaper supermarket brands. Paper is sold in different weights, measured either in grammes per metre squared (gsm), for example 250gsm, or imperially in pounds, such as 300lbs. The greater the number, the thicker and heavier the material will be. Many inkjet printers will have maximum and minimum paper thickness limits with the better ones accepting card-like 350gsm.

PROFESSIONAL RESIN-COATED INKJET PAPER

Like conventional photographic paper, resin-coated inkjet papers gives you high colour saturation and the finest detail. Gloss papers have a shiny topcoat enhancing the depth of a print's blacks and shadow areas; most light is reflected from this kind of media. Matt surfaces, however, give a less intense result and much a weaker black.

BARYTA PAPER

Baryta is a barium sulphate coating that is applied to fibre-based paper. The Baryta layer improves definition and detail. For example, Harman Photo's Matt FB Mp Warmtone is a brand that feels like traditional fibre-based photographic paper. The paper is heavyweight, manufactured at 310gsm, close to a double weight conventional photographic paper and includes a Baryta layer.

6.7a

6.7b

6.8

COTTON/ARCHIVAL PAPERS

Greater image permanence can be gained from handmade papers, which by their very nature use less chemical agents in their preparation. These papers are generally made from virgin materials including linen rags and cotton, and are made one sheet at a time. The vatman dips a rectangular sieve (the deckle) into the vat and pulls out a quantity of watery pulp, shaking to mesh the fibres together and drain off excess water. Edges can be modified, too, with deckled or untrimmed finishes.

ALTERNATIVE PAPERS

Inkjet printers can use unconventional media, too, such as artist's paper. These papers absorb more than conventional inkjet media and as a result are much less reflective. Each kind of art paper has its own base colour ranging from ivory, off-white through to cream, yellow and even salmon pinks. Inkjet printers are never equipped with white printing ink, so it's important to recognize that the base colour of, for example, your watercolour paper will become the maximum highlight colour and value in your final print.

After making your initial test prints, you'll notice that your results will look oddly dark and have a much less saturated range of colours compared to a monitor image. Due to the open weave and texture of many paper materials, high-resolution files with pin-sharp detail will not reproduce well and contrast can be flat and muddy.

Both Somerset Velvet Enhanced and Lyson Fine Art share the quality and feel of a handmade material, but with the added advantage of a specially designed surface coating to improve image sharpness.

6.9

6.9

Bought in a single sheet or part of a sketch block, watercolour papers can be unpredictable but produce a wonderful textured result that is a perfect crossover between painting and photograph.

PRINT PROFILES – ESSENTIALS

Print profiles help to get the very best
quality out of your workflow, reduce
wasted time and materials, and produce
a print that is visually closer to the image
viewed on your monitor display.

WHY USE PROFILES?

There's no reason to use print profiles if you
use an Epson, Canon or HP printer, along
with the same brand of ink and paper. When
printer manufacturers design their unique
printer drivers, they include purpose-made
profiles for each of their own type of media
within the driver itself. However, if you want to
experiment with third-party papers and inks,
printing with a profile is essential.

Although most third-party papers are
supplied with recommended printer driver
settings, these rarely produce adequate
results when compared with prints made with
purpose-made profiles.

HOW PROFILES WORK

No Epson printer driver knows how to
convert the colour of each pixel into the exact
proportions of ink colours to get the best out
of a third-party paper. Instead, the third-
party paper manufacturer provides a small
file for you to bolt-on to your workflow. This
file translates the pixel colours in your image
into ink values for a specific paper, printer and
inkset combination. In reality, profiles are tiny
data files, often no bigger than 100K in size,
identified by their file extension ending in
either .icc or .icm.

6.10

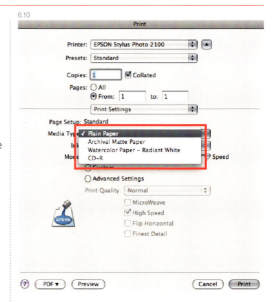

WHERE TO GET PRINT PROFILES

Third-party paper manufacturers provide
free profiles for download from their
company websites. All of the bigger paper
manufacturers provide support for the latest
Epson and Canon photo-quality printers, but
not necessarily for office desktop printers or
discontinued models. If you are considering
buying a printer, it is a good idea to check if
your favourite paper manufacturer supports
your desired device. Less support is available
for HP inkjets.

6.11

6.12

6.13

HOW PROFILES ARE MADE

Print profiles work by linking three critical variables together: printer model, ink type and paper type. Each profile document can only support one configuration of these three variables, so if one of these are changed, the profile is useless. Once each tiny colour patch is scanned, profiling software estimates the characteristics of the colour, and then makes a recommended ink recipe. Many professional photographers make their own bespoke profiles to fit their own unique workflows.

HOW TO LOAD THE PROFILES INTO YOUR SYSTEM

After finding the correct section on the website for your printer and ink type, the specific paper profile is downloaded to your desktop. Profiles must be placed in the correct folder, or they won't work.

6.11
Most profiles are available free, via the paper manufacturer's website, and are made by printing out a standard colour test chart using the desired printer, ink and paper combination, which is then scanned by a spectrophotometer, as shown.

6.12
On an Apple OSX system, drag the profile into Library > Color Sync > Profiles, as shown.

6.13
On Windows it's even simpler. Once the profile appears on your desktop, right click on its icon and choose the Install Profile option, as shown. The profiles are placed in the Windows\system32\spool\drivers\color folder.

USING PROFILES FOR PRINTING

Profiles are used instead of your printer software and guarantee better results with much less wastage.

IN PHOTOSHOP
After editing your image, go to the Print dialog and choose your target printer; set with your desired paper size and print layout. There's no need to flatten your image before printing; you can print direct from your layered work-in-progress file.

6.14a

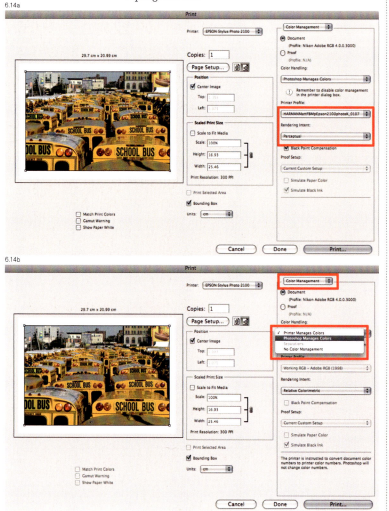

6.14b

Step 1: Use Photoshop as the colour handler
Click in the Output drop-down menu, then choose the Color Management option. Next, deselect the default setting Printer Manages Colors, replacing it with Photoshop Manages Colors option from the Color Handling pop-up menu, as shown. This gives Photoshop the responsibility for converting pixel colour into ink colour, based on the profile you will use.

Step 2: Choose your profile
In the Printer Profile drop-down menu, scroll until you find the profile for your chosen paper. The file naming protocol for profiles usually includes the paper, printer and black inkset within its title.

Step 3: Check your paper instructions
Refer to the instruction sheet that accompanied the downloaded profile, or provided with your third-party paper. The instructions should tell you which of the Rendering intents to choose. The four commonly used rendering intents work like different translation styles, each providing a subtly different result. Most papers use Relative Colormetric or Perceptual rendering intents.

Set the Rendering intent; for this paper, Perceptual is the recommended option. Now press Print.

Step 4: Configure the Printer software
After entering the Printer software dialog, the next step is to match the Media Type to the profile's instruction sheet. For this paper, Watercolour Paper-Radiant White is the recommended media type, together with the 1440dpi print quality. It's important to match these settings to your paper, but if your instructions don't specify the media, experiment with the closest surface types available in your printer software.

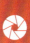

Step 5: Switch off colour management

The final step is to switch off the printer software's own colour management functions, so that Photoshop and the profile have the sole responsibility for translating pixel colour into ink. Choose the No Color Adjustment option, and then press Print.

Step 6: Save your settings

Repeating this six-step process every time you want to print is tiresome, so save your settings for easier reuse. Before printing, select the Save As option and name with the paper brand name. This becomes available as a Preset, as shown in image 6.15a.

USING LIGHTROOM

Lightroom provides a simpler interface for printing with profiles, by making them visible within the full-screen Print module. Scroll to the Colour Management panel, and then choose the Profile from the Output menu. If you are using the profile for the first time, pick it from the dialog that'll appear on your desktop. Now, rejoin the process at Step 3.

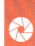

180

6.16
This example from Photobox was printed on 6x4.5 inch paper, keeping the full-frame image, which would have been cropped on 6x4.

6.17a–6.17b
After processing your file using Photoshop, go to Image Size and set the Resolution to 300ppi. Next, go to Edit>Convert to Profile and change the profile to sRGB, as shown. Choose Flatten to merge your adjustment layers. Finally, Save As using the JPEG format, compressing to quality level 10. This setting provides the best trade-off between data saving and image quality.

PRINTING THROUGH AN ONLINE MINI-LAB

Although the photographic processing industry has collapsed in recent years due to the dominance of home inkjet printing, several online mini-lab printing services remain.

WHAT IS A DIGITAL C-TYPE?
Before digital sensors and inkjet printers were invented, all professional and amateur photographers used the same kind of light-sensitive colour printing paper, called C-type. Digital C-type prints are printed using a laser or LED imaging device, which 'beams' light onto photographic paper, much like an old-fashioned enlarger projected light onto sensitive materials. After the photographic paper is exposed, it is then fed into a chemical colour print processor where it emerges washed and dried after 8–10 minutes.

USING AN ONLINE MINI-LAB
If you have a large number of files to print onto small-sized photographic paper, then it can be more economical to use an online lab rather than a desktop inkjet. Photobox. co.uk is an online lab that has gained a good reputation for quality, speed and competitive pricing. The service offers free online storage, so you can upload and order prints at your convenience. Operated through a standard web browser, Photobox also provides a useful print preview function, so you can see how the aspect ratio of your file sits within your chosen paper size. If it's cropped unfavourably, you can simply choose another paper size.

6.16

PREPARING YOUR FILES
Online mini-labs provide a very economical way of making prints without the need for a professional inkjet printer, expensive paper and setting-up time. Most mini-labs provide prints limited in size to 12 inches wide, as they are processed using roll-fed paper on a mini-lab machine. Accessed through a simple browser and uploaded as individual files, dispatching your work is very simple. Final files need to be prepared as JPEGs in the sRGB colour mode, with no layers, and set to 300ppi.

6.17a

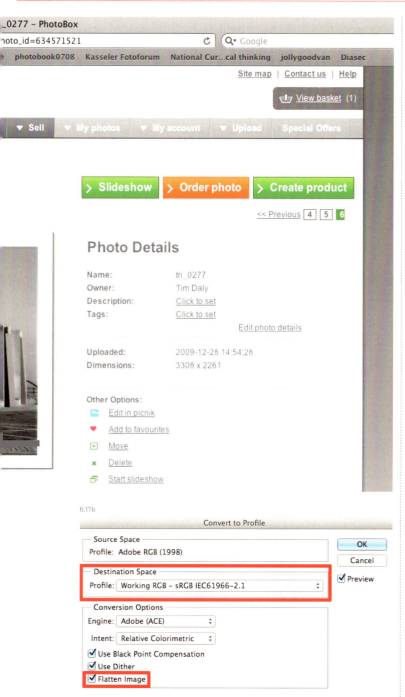

6.17b

USING LIGHTROOM

Packaging files for online printing with Lightroom occurs during the Export function, which can be applied quickly to a batch of files. Click select all those image for printing, then do File>Export and create your settings.

LONGEVITY

Good-quality C-type papers, such as Fuji Crystal Archive, are resistant to fading, provided fresh chemicals are used and they are washed according to manufacturers' guidelines. Crystal Archive has a lifespan of around 50–60 years before noticeable colour change takes place, and for prints stored in albums or away from atmospheric pollutants, the lifespan can be considerably longer. C-types are an ideal medium for commercial print sales and are widely used by wedding and portrait photographers.

MAKING A DIGITAL C-TYPE PRINT AT A PRO-LAB

The finest quality photographic print, the digital C-type is best made through a professional photographer's lab.

6.18

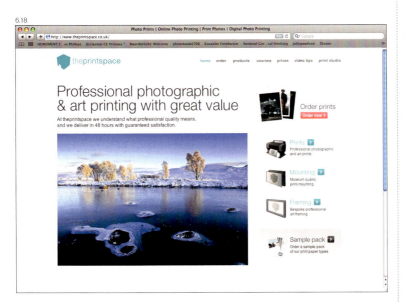

6.18

At theprintspace, prints are available as a walk-up service or via an online ordering service (see www.theprintspace.co.uk). Theprintspace provides profiles for all their paper types, so you can fully manage colour from your own desktop.

PROFESSIONAL LAB SERVICES

Many professional photographers use pro-labs to make conventional colour prints, called 'digital C-types', from their files. Yet, despite this professional tag, print prices are not as expensive as you might think. Unlike inkjet systems, C-type processes offer a limited selection of papers and finishes, typically gloss and semi-gloss or lustre, but provide a much richer colour gamut and dynamic range than all but the most expensive inkjet systems. For monochrome photographers, lab output offers a great opportunity to make richly toned prints for exhibition or sale.

MAKING DIGITAL C-TYPES WITH THEPRINTSPACE PRO-LAB SERVICE

Although there are many Internet-based photo labs offering cheap C-type prints from your JPEG files, they rarely provide downloadable profiles, so they don't provide the same level of control to the user. Most online mini-labs also apply an unknown amount of auto-processing to your submitted files, such as auto contrast and auto sharpening, so the results can look very different to your expectations. Better pro-labs, such as theprintspace avoid processing your images, so you can determine the final look of your print, albeit for a higher price. Online labs don't accept layered images, so your files must be flattened before sending and many only accept JPEGs. Files must also be rendered back to 8-bit mode before uploading.

PROFILES AND REMOTE PRINTING

Sending an image file to a remote printing service differs from desktop printing to an inkjet in one crucial respect: the print profile is embedded into the file as part of the workflow. When desktop printing, print profiles are never 'baked' into the file, but used as a temporary translator between printer and image file.

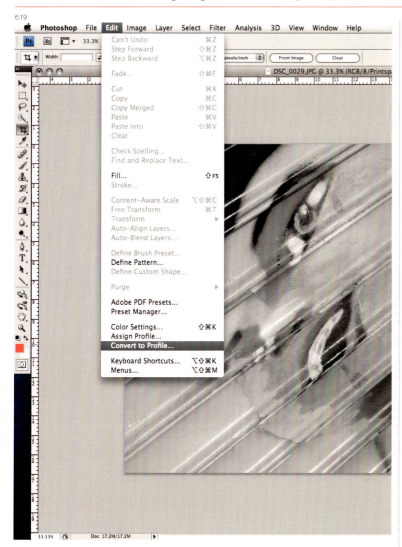

STEP 1

Once you have chosen your professional service provider, download the profile pack for their C-type papers. After installing the profiles, edit your file. When complete, do Edit>Convert to Profile (see image 6.19).

STEP 2

Next, choose your paper profile in the Destination space and match the recommended rendering intent as per profile instructions (see image 6.20). These settings will be identical to the setting used in your soft-proofing view. For this example, the Fuji C-Type Glossy media was chosen.

STEP 3

Finally, do File > Save As and rename your file, so you don't overwrite your original source file. It's now ready to send. When it arrives at the other end, the colour is already translated to the correct 'language', so no unexpected adjustments take place. Digital C-types are a great way of making toned or tinted monochrome prints, as the gamut (or range) of the paper is far higher than any inkjet printing device.

184

PHOTO BOOK PRINTING

Many photographers are using the book form as another promotional tool and, because it's available at low cost, there's never been a better time to self-publish your work.

6.21

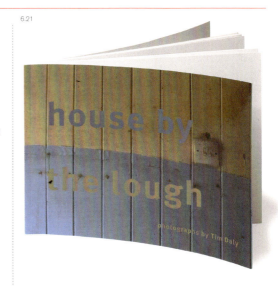

6.21

The author's own on-demand book printed via Lulu.com.

ON-DEMAND PRINTING

Photography has now entered its third revolution, little more than 15 years after digital technology changed it forever. Running alongside the development of the photographers' favourite, the desktop inkjet printer, another revolution in the commercial printing industry has gained momentum.

The new digital printing press shared much technology with the humble inkjet and unlike conventional litho-printing presses, could be configured to produce one print rather than several thousand of the same document. This capability to cater for short or even single-run jobs enabled the growth in popularity of the digital photo book. Combined with the development of e-commerce and the rise in popularity of buying goods and services online, a number of photo-book service providers have seized the opportunity to offer high-quality books at low cost, produced without the need to purchase professional design software.

BLURB

One of the better on-demand photo-book printers, Blurb offers plenty of help to get your project in print. Blurb's book printing services provide plenty of different formats, finishes and sizes of book to choose from, starting with high-volume paperbacks through to high-quality hardbacks for special occasions. Blurb provides a freely downloadable book-design application, BookSmart, so you can lay out your content. It also supplies InDesign templates for those who prefer to submit their own press-ready pdfs. With an effectively organized shop front, called the Bookstore, your books can be placed on sale, too. The website offers plenty of tools for users to administer their projects, contact details and royalty payments. Like most other online sellers, you can easily track the number of copies sold by logging into your unique admin area.

6.22

6.23

THE NEW PORTFOLIO

The digital photo book is already becoming the favoured presentation medium for photographers, designers and visual artists. With the ability to drive the complete production process from a desktop computer, photo books are now replacing the clunky portfolio as a sleeker and more professional way to present a proposal or finished project.

6.22

Once your book is laid out, BookSmart creates a repro-ready file for online submission to Blurb. BookSmart also allows you to save your project file, through a File>Export command, creating a book format file that can only be reopened in BookSmart, but offering you the flexibility to work on your project elsewhere.

6.23

If you prefer to layout using a professional desktop publishing application, such as InDesign, Blurb provides free templates for you to use, which prepare your artwork to get the very best out of their printing press.

MAKE YOUR OWN PHOTO BOOK

Turning your finished project into a photo book is a good way of disseminating your work and is not as expensive as you may think.

6.24

6.24
This handmade book was made by stitching cotton paper prints together and interweaving found objects.

DRAG AND DROP WITH BOOKSMART AND LIGHTROOM

Like many other on-demand printing services, Blurb offers their software, BookSmart, free to registered users. The application is available for both Mac and Windows PC users. BookSmart is primarily aimed at non-designers and is equipped with plenty of layout tools to help position both images and text. Once launched, BookSmart prompts you to choose the style and shape of your book, but like all other decisions made in the application, this is reversible at all times.

The book project is essentially divided into two components: the cover and the insides, and BookSmart allows you to add, move and delete individual pages as you work. Each of the two components has a set of pre-designed templates, which you can use to provide the layout grid for your book.

Lightroom 4 has a built-in Book module, specially designed to link with Blurb's on-demand service. With no need to duplicate image files, preparation, proofing and layout can all be created in Lightroom.

HANDMADE BOOK

Handmade books have a very different feel compared to an on-demand product, creating a tactile and unique volume. Although book binding can seem initially complex, little specialized equipment is needed to make a handmade photo book, and specialist materials can be sourced from bookbinding suppliers. One advantage of making your own books is that you are not limited by the format, size or shape of a commercial photo book service, so you can design and construct to fit your own plans.

6.25a

6.25b

6.25c

PERFECT-BOUND PHOTO BOOK

Perfect binding is a quick and inexpensive way of making a unique photo book of your existing prints for roughly the same price as an on-demand book. This process is familiar to us all, just look at the top of any paperback and you'll spot a thin section of glue that's keeping all the separate sheets in place. Although it's not as permanent as a sewn binding, perfect-bound books are capable of withstanding many years of use, with sensible handling. Most paper materials are suitable for binding in this way, so any combinations of different paper colours, weights and textures can be incorporated into the same book, placing this kind of photo book well above the mass-produced digital on-demand product. Get your set of prints perfect bound at any high street printing franchise.

6.25a–6.25c
This perfect-bound book was produced from one single Photoshop document, each image arranged as a separate layer and printed out under the same conditions to ensure consistency.

6.26

188

In this example, a negative film was first produced then contact printed onto a sheet of sensitized salt paper under the controlled exposure conditions of a UV printing frame used for silkscreen printing, but you can just as easily use a clip frame left in sunlight.

ALTERNATIVE OUTPUT

Many digital photographers' work looks the same because they use identical tools and workflows. If you want to develop a personalised approach to printing there's plenty of alternative methods to try.

LIQUID INKJET COATING

The liquid inkjet coating InkAid (see www.inkaid.com) can be painted onto unconventional media, such as uncoated artist's paper, wood, metal, ceramics and textiles, creating a purpose-made surface for regular inkjet ink to sit upon. Aimed originally at artist printmakers rather than photographers, transparent InkAid is designed to work closely with modern pigment inks and desktop inkjet printers. It is ideal for making mixed-media prints where you could combine photographic images with painting or another printing technique (see image 6.27).

INKJET TRANSFER PRINTS

Inkjet transfers can be made when a wet print is pressed into contact with another sheet of paper. An inkjet transfer print can be made using standard inkjet materials and printers, to create an unrepeatable one-off print. The process is similar to Polaroid transfer prints, but without the restriction on size, shape and budget. Like the Polaroid process, inkjet transfers don't permit fine details, sharpness and colour accuracy, so it is wise to modify your expectations from the start. Although any absorbent papers can be used to receive the image, best results come from purpose-made inkjet papers, especially the thicker Baryta-type media.

Using the right kind of donor media is key to this process. The best type is the plastic film that holds ink droplets without puddling, but most importantly doesn't dry. After the film emerges from your desktop inkjet, it's essential to place the donor paper in contact with your receiving paper as soon as possible, before the ink starts to dry, using a roller to force the two sheets together (see images 6.28a and 6.28b).

6.26

6.27

VINTAGE PRINTING

Printing your digital images onto high-resolution clear film with an inkjet, allows you to make a digital negative – which can be used to recreate most nineteenth-century photographic printing processes. The inventor of negative/positive photography William Henry Fox Talbot developed the first of many printing-out papers (POP), made by pressing negatives against light-sensitive paper under a strong light source until the paper visibly darkened.

6.28b

6.28a

6.29

6.29
Talbot's Salt printing process is very easy to recreate needing nothing more than silver nitrate, salt and some sheets of tactile watercolour paper.

ASSIGNMENT: MAKE A POP-UP EXHIBITION

One way to display your work is by making a pop-up exhibition by creating a folded photo book.

THE BRIEF

Planning a sequence of images for a book, exhibition or a slideshow can be a fraught experience. For this project, create a single accordion-fold print containing twelve or more images. Once printed, the paper is to be scored and folded, backed with card and made into a pocket-sized artefact. Once complete, the book can be opened out on a shelf as a ready-made display of your work.

You must produce the following:

1 A contact print with all your chosen images.
2 A mock-up of your accordion-fold print, showing the position of your chosen images together with fold and crop marks.
3 A finished accordion-fold print.
4 A separate written evaluation describing what you have learned during the project.

6.30
This is an image from Federico Clavarino's photo book called *Ukraina Passport.*

6.30

6.31

6.31

Peter Dekens' accordion
fold book *Touch* creates
a very different kind of
book object and forces
the reader to interact
with the subject in
a more tactile way.

CONCLUSION

Studying photography at university or college will enable you to develop your own individual approach in a supportive setting, but what do you do when you've completed the course? If you want to keep learning and improving your work, you'll need to obviously keep shooting, but you'll also need to spend time keeping connected. Subscribing to a critical journal like *Aperture* or an industry monthly, such as *The British Journal of Photography*, is an easy way to keep in touch.

Across the UK, US and Europe there are also annual photo industry trade fairs, such as PhotoPlus in New York, Focus on Imaging in the UK and Photokina in Germany, where you can keep up with the latest equipment and services. Paris Photo, which runs in the autumn each year, is the biggest and best celebration of all things photographic from vintage prints to the latest contemporary work and photo books.

Les Rencontres d'Arles, Visa pour L'Image at Perpignan and Noordelicht in the Netherlands are annual celebrations of documentary photography and photojournalism – are all great places to see emerging talent and become inspired.

In addition to this, you should also consider joining a collective or local group of like-minded practitioners. The Royal Photographic Society and London Independent Photography (LIP) are two organizations that provide events and workshops, so you can meet up with fellow creatives. There are also several online groups, many often started by individuals who want to connect with other photographers worldwide to share ideas and make work for a show or a book publication.

There's nothing more motivating than developing a project for future exhibition, as this will provide you with the impetus to make work, make prints and give closure to a project idea. Many cities in the UK hold annual photography festivals, such as Photomonth in East London, the Brighton Photo Biennial and Format International Photography Festival in Derby – these are a great opportunity for you to show either as part of the curated programme or as a fringe event that you've organized yourself with like-minded collaborators.

Finally, despite the many wonderful resources available on the Internet, there's nothing quite like seeing photographic prints for real. Subscribe to the mailing lists of major galleries and make the effort to go and see curated shows at national and international galleries.

GLOSSARY

Aperture The adjustable opening inside your camera lens that lets light pass onto your digital camera sensor. Like the pupil in your eye, bigger apertures let in more light when it's dark and smaller apertures let in less light when it is too bright. Aperture values are described in f numbers, such as f8.

Artefacts Are by-products of digital processing, such as noise, which degrade image quality.

Bit The smallest unit of digital data representing on or off; 0 or 1; or black or white.

Bit depth Also referred to as colour depth, this describes the size of the colour palette used to create a digital image, for example, 24 bit. The bigger the number, the more colours.

Bitmap image Another term for a pixel-based image arranged in a chessboard-like grid.

Bulb shutter speed Despite its name, the bulb setting has nothing to do with flash photography. Identified as 'B' on your shutter-speed dial, it keeps the shutter open for as long as you keep your finger on the shutter release.

Card reader Digital cameras are sold with a connecting cable that fits into your computer. A card reader is an additional unit with a slot to accept camera memory cards for faster computer transfer.

Clipping This happens when image tone close to highlight and shadow is converted to pure black and white during scanning. Loss of detail will occur.

CMYK image mode Cyan, Magenta, Yellow and Black (called K to prevent confusion with Blue) is an image mode used for litho reproduction. All magazines and books are printed with CMYK inks.

Colour space RGB, CMYK and LAB are all kinds of different colour spaces, each with their own unique characteristics and limitations.

Compression Reducing digital data into smaller packages or files is known as compression. Without physically reducing the pixel dimensions of an image, compression routines employ compromise colour recipes for groups of pixels, rather than individual ones.

Contrast High-contrast images have bright whites, pure blacks and few grey tones or colours. Low-contrast photos are the exact opposite with few whites or blacks, and many middle greys in their place. High-contrast photographs look punchy and low-contrast photographs can look dull.

CPU The Central Processing unit is the engine of a computer, driving the long and complex calculations when images are modified.

Curves A versatile tool for adjusting contrast, colour and brightness by pulling or pushing the line.

Depth of field The amount of sharp detail that you can set between the foreground and background of your image. Smaller f numbers give less depth of field and bigger f numbers give more depth of field.

Driver A small software application that instructs a computer how to operate an external peripheral piece of hardware, like a printer or scanner. Drivers are frequently updated, but are usually available for free download from a manufacturer's websites.

Dynamic range A measure of the brightness range that can be captured by photographic materials and digital-sensing devices. The higher the number, the greater the range.

Exposure modes Many cameras use two common auto modes to give you more time to enjoy taking pictures. The 'aperture priority' mode makes the camera set an automatic shutter speed to complement your choice of aperture. The shutter speed priority mode makes the camera set the right aperture to fit your choice of shutter speed.

File extension The three- or four-letter/number code that appears at the end of a document name, preceded by a full stop (for example, landscape.tif). Extensions enable applications to identify file formats and enable files to be read across different computers and software applications.

FireWire A fast data-transfer system used on recent computers, especially for digital video and high-resolution image files. Also known as IEEE1394.

f numbers Aperture values are described in f numbers, such as f2.8 and f16. Smaller f numbers allow more light and bigger numbers allow less light to pass through your lens and onto your sensor. F numbers also influence your depth of field.

Focal length The amount of a scene you can see through your lens is determined by its focal length, which is measured in millimetres. The smaller the number, the more you can see through your lens. You can see more through a 28mm wide-angle lens than you can through a 50mm standard lens.

Gamma The contrast of the midtone areas in a digital image.

Gamut A description of the extent of a colour palette used for the creation, display or output of a digital image.

GIF Graphics Interchange Format is a low-grade image file for monitor and network use, with a small file size due to a reduced palette of 256 colours or less.

Grayscale This mode is used to save black-and-white images. There are 256 steps from black to white in a greyscale image, just enough to prevent banding to the human eye.

Halftone An image constructed from a dot screen of different sizes to simulate continuous tone or colour. Used in magazine and newspaper publishing.

Highlight The brightest part of an image, represented by 255 on the 0–255 scale.

Histogram A graph that displays the range of tones present in a digital image as a series of vertical columns.

Inkjet An output device that sprays ink droplets of varying size onto a wide range of media.

Interpolation Also known as 'resampling', this describes how a digital image can be enlarged or reduced by adding or subtracting pixels from the original bitmap grid.

ISO Speed Photographic film and digital sensors are graded by their sensitivity to light. This is sometimes called 'film speed' or 'ISO speed'. Fast speeds, such as ISO 800, allow you to take pictures of fast-moving subjects and shoot in low-light conditions.

JPEG Digital cameras can create and store your pictures as JPEG files. Most computers and computer software accept these universal file types. JPEGs are useful because they squeeze, or compress, all the instructions needed to recreate a digital picture, allowing you to fit many pictures onto your memory card. JPEG files use a lossy compression routine, which leads to a reduction in image quality.

Lens flare If you take pictures while pointing your camera at a bright light source like the sun, you will get lens flare on your prints. Flare looks like a milky haze or a set of translucent discs overlaying the image.

Levels A common set of tools for controlling image brightness found in Adobe Photoshop and many other imaging applications. Levels can be used for setting highlight and shadow points.

Megabyte (Mb) 1024 kilobytes of digital information. Most digital images are measured in Mb.

Megapixel A measurement of how many pixels a digital camera can make. A bitmap image measuring 4000x3000 pixels contains 12 million pixels (4000x3000=12 million), made by a 12-megapixel camera.

Noise Like grain in traditional photographic film, noise is an inevitable by-product of shooting with a high ISO setting. If too little light passes onto the CCD sensor, brightly coloured pixels are made by mistake in the shadow areas.

Peripherals Items used to build up a computer workstation, such as scanners, printers, CD-writers and so on.

Pigment inks A more lightfast inkset for inkjet printers, usually with a smaller colour gamut than dye-based inksets. Used for producing prints for sale.

Pixel Taken from the words 'picture element', a pixel is the building block of a digital image, much like a single tile in a mosaic. Pixels are generally square in shape.

Profile The colour reproduction characteristics of an input or output device. This is used by colour management software, such as ColorSync, to maintain colour accuracy when moving images across computers and input/output devices.

RAM Random Access Memory is the part of a computer that holds your data during work in progress. Computers with little RAM will process images slowly as data is written to the hard drive, which is slower to respond.

RAW A RAW file is a generic term that describes an image, which has been saved without in-camera settings embedded. Camera manufacturers, such as Nikon and Canon, have developed their own variants of the RAW file, with the extensions .NEF and .CR2 respectively.

Resolution The term resolution is used to describe several overlapping things. In general, high-resolution images are used for printing out and have millions of pixels made from a palette of millions of colours. Low-resolution images have less pixels and are only suitable for computer monitor display.

RGB image mode Red, Green and Blue mode is used for colour images. Each separate colour has its own channel of 256 steps and pixel colour is derived from a mixture of these three ingredients.

Selection A fenced-off area created in an imaging application like Photoshop, which limits the effects of processing or manipulation.

Shadow The darkest part of an image, represented by 0 on the 0–255 scale.

Sharpening A processing filter that increases contrast between pixels to give the impression of greater image sharpness.

TIFF Tagged Image File Format is the most common cross-platform image type used in industry.

Unsharp Mask (USM) This is the most sophisticated sharpening filter found in many applications.

White balance Digital cameras and camcorders have a white balance control to prevent unwanted colour casts. Unlike photographic colour film, which is adversely affected by fluorescent and domestic lights, digital cameras can create colour-corrected pixels without using special filters.

Wide-angle lens These are ideal when you are shooting in confined spaces (indoors). They have the opposite effect to telephoto lenses and push your subjects away from you. If you use a wide-angle lens to take pictures of people, their faces can appear distorted.

Zoom lens A zoom lens gives you freedom to frame subjects near and far away, without moving your own position. A zoom lens, such as a 20–100mm, is a wide angle, a standard and a telephoto rolled into one. A macro zoom also allows you to focus on objects that are extremely close to your lens.

SUPPLIERS

Archival storage systems
www.dickblick.com

Camera bags and luggage
www.billingham.co.uk
www.crumpler.com
www.lowepro.com
www.tenba.com

Colour-calibration equipment
www.datacolor.com
www.lacie.com
www.xrite.com

Computer monitors and tablets
www.eizophoto.com
www.lacie.com
www.nec.com
www.samsung.com
www.wacom.com

Computer workstations
www.apple.com
www.dell.com

Digital camera memory cards
www.delkin.com
www.lexar.com
www.sandisk.com

Digital cameras
www.canon.com
www.fujifilm.com
www.hasselbladusa.com
www.leafamerica.com
www.leica.com
www.nikon.com
www.olympus.com
www.panasonic.com
www.pentax.com
www.sony.com

External storage drives
www.drobo.com
www.iomega.com
www.lacie.com
www.westerndigital.com

Image-editing software
www.adobe.com
www.alienskin.com
www.autofx.com
www.flamingpear.com
www.niksoftware.com
www.ononesoftware.com

Inkjet printers
www.canon.com
www.epson.com
www.hp.com

Mount cutting and framing
www.dickblick.com
www.framersisland.com
www.logangraphic.com

Paper and printing media
www.breathingcolor.com
www.canson.com
www.epson.com
www.hahnemuehle.com
www.harman-inkjet.com
www.ilford.com
www.inkjetmall.com
www.inkpress.com
www.inveresk.co.uk
www.kodak.com
www.lyson.com
www.moabpaper.com
www.permajet.co.uk

Photo-book services
www.artefactstudio.com
www.asukabook.com
www.blurb.com
www.bobbooks.co.uk
www.lulu.com
www.photobookpress.com
www.pikto.com
www.whcc.com
www.yophoto.co.uk

Photo-sharing communities
www.flickr.com
www.livebooks.com
www.photobox.co.uk
www.photoshop.com
www.picasa.google.com
www.smugmug.com

Photography retailers
www.bhphotovideo.com
www.calumetphoto.com
www.fotocare.com

Portable printers
www.canon.com
www.polaroid.com
www.sony.com
www.zink.com

Presentation and portfolios
www.houseofportfolios.com
www.lost-luggage.com
www.modernpostcard.com

Royalty-free image libraries
www.alamy.com
www.istockphoto.com

Tripods
www.gitzo.com
www.manfrotto.com

INDEX

ACKNOWLEDGEMENTS AND CREDITS

The publishers would like to thank Paul Antick, Frank Balaam, Richard L. Fuller and Steven Tynan.

p. 10 Simon Barber/Millennium Images, UK
p. 11 courtesy of Canon
p. 12 courtesy of Nikon, UK
p. 13 courtesy of Olympus; courtesy of Fuji
p. 14 courtesy of Phase One
p. 15 courtesy of Capture One
p. 16/17 courtesy of Nikon, UK
p. 20 © Henry Lowther; courtesy of Nikon, UK
p. 21 courtesy of Canon
p. 22 bikeriderlondon/shutterstock.com; courtesy of Canon
p. 23 courtesy of Nikon, UK
p. 34 Joachim Wendler/shutterstock.com
p. 35 © LaCie; Picture courtesy of Connected Data
p. 41 © Chris Killip
p. 44 © Sally Rose McCormack
p. 50 courtesy of Nikon, UK
p. 52 Cristina Garcia Rodero/Magnum Photos
p. 53 Francisco Aires Mateus/www.ultimasreportagens.com
p. 54 © Bertie Gregory
p. 57 Niall McDiarmid / Millennium Images, UK
p. 64 Olivia Arthur/Magnum Photos for Water Aid
p. 68 Maxisport/Shutterstock.com
p. 78 www.emergillespie.com
p. 79 Hans Eijkelboom/www.photonotebooks.com
p. 85 © Michiko Kon Courtesy of Photo Gallery International
p. 87 courtesy of Jo McGuire
p. 89 © Ricardo Cases
p. 91 Irina Popova © www.irinapopova.net
p. 92 Arnis Altens/Millennium Images, UK
p. 93 Emilio Brizzi/Millennium Images, UK
p. 95 Lee Avison/Millenium Images, UK; Richard Tuschman/Millenium Images, UK
p. 97 John Stezaker Image: Alex Delfanne/Courtesy of The Approach, London
p. 99 Colin Dutton/Millenium Images, UK
p. 100 © Rinko Kawauchi
p. 101 Simon Carruthers/Millenium Images, UK
p. 102 Paulo Pellegrin/Magnum Photos
p. 105 © Rob Wilson/Millennium Images, UK
p. 108/109 Thomas Hoepker/Magnum Photos; courtesy of Emma Lavender
p. 110/111 Tim Hetherington/Magnum Photos
p. 112 © Hilary Walker/Millennium Images, UK
p. 113 © Toumpanos Leonidas/Millennium Images, UK
p. 114 Hans Eijkelboom/www.photonotebooks.com
p. 115 © Mark Power

p. 119 © 2013. Image copyright The Metropolitan Museum of Art/Art Resource/Scala, Florence
p. 121 © Josef Koudelka/Magnum Photos
p. 124/125 © Chris Steele-Perkins/Magnum Photos
p. 127 © Steve McCurry/Magnum Photos
p. 130 Spencer Platt/Getty Images
p. 134/135 courtesy of Emma Lavender
p. 140 phloxii/shutterstock.com
p. 142 courtesy of Katie Treadwell
p. 143 Martin Parr/Magnum Photos
p. 150 cardaf/shutterstock.com
p. 153 de marco/shutterstock.com
p. 157 L. Watcharapol/shutterstock.com
p. 169 © Oli Kellet
p. 177 X-Rite Incorporated
p. 190 © Federico Clavarino 2011
p. 191 © Peter Dekens
All other images are courtesy of Tim Daly.

All reasonable attempts have been made to trace, clear and credit the copyright holders of the images reproduced in this book. However, if any credits have been inadvertently omitted, the publisher will endeavour to incorporate amendments in future editions.